Stories of Images

for Neil
with best wishes from
uncle Henry

Henk van Os

Stories of Images

This publication was made possible by a grant from the University of Amsterdam.

Stories of Images is based on the Dutch television program *Beeldenstorm* by the AVRO.

Translated from the Dutch by Wendie Shaffer.
Cover design and lay out: Pinxit, Amsterdam
Photo cover: Maarten Corbijn, Amsterdam

ISBN 90 5356 558 2
NUR 640

© Salomé – Amsterdam University Press, 2002

All rights reserved. Without limiting the rights under copyright reserved above, no part of this book may be reproduced, stored in or introduced into a retrieval system, or transmitted, in any form or by any means (electronic, mechanical, photocopying, recording, or otherwise), without the written permission of both the copyright owner and the author of this book.

Contents

CENTRAL LIBRARY
WITHDRAWN
THE BRITISH MUSEUM
9412
BM? (DSN)

Foreword

In the book *Stories of Images*, Henk van Os, former director of Amsterdam's Rijksmuseum, has selected some of the most intriguing accounts from his TV programme on art. The series has been running for several years now with major success, presenting a 10-minute show on Dutch TV on Sundays in which professor Van Os talks about a work of art, in his own inimitable manner. Millions of Dutch people are his devoted fans, looking forward each week to a new cultural eye-opener.

What is the secret of Henk's success? I think the most important factor is this: Henk is quite clearly passionate about his subject and, while being an expert in his field of Art History, is able to look at art with the eyes of the interested layperson. He makes art alive and exciting. He takes you gently by the hand and leads you into a world that for many remains obscure and uninviting. And without having to make a huge effort, you find yourself looking at art in a new way, fired by Henk's enthusiasm.

Henk is a born storyteller – he speaks vividly about the things that fascinate and intrigue him, about the works of art that he enjoys and would like others to appreciate. His approach is influenced by his Dutch background – for him, the cultural heritage of the Low Countries is something for everyone to share. People who feel they don't know much about this culture, who sense their difference, are also welcome. It doesn't matter what you know or don't know – just join in and look. Henk is a true Leveller and addresses everyone who wants to listen.

In a way, what Henk does is to bring art out of the museums and into people's homes. He hopes that in this way people will want to visit the places where they can see the originals. After all, many great art collections are now public, art museums have become common property. With this lively guidebook in our hands, we can go out and enjoy.

Wim Kok, former Prime Minister of the Netherlands

Introduction

This book is a collection of stories about some of the most well-known (and some lesser known) works of art from the Low Countries. It contains a selection of texts from a series of books based on a popular Dutch TV series that has been running since 1990. The original idea of the programme was to present some highlights of the collection in the Rijksmuseum, Amsterdam. When I was appointed director of the museum in 1989 I was struck by the fact that less than 15 percent of the annual total of around a million visitors were Dutch. So why weren't the Dutch particularly interested in their artistic heritage? Was it because museums and art seemed stuffy, or was it quite simply that people didn't know what they were missing? I thought the latter answer more likely. The TV series proved a great success, and together with a shake-up in the publicity and exhibition organization of the museum, things took a new turn. When at the end of 1996 I retired as director of the Rijksmuseum, more than half of the total annual visitors were Dutch.

So much for the beginnings. The chief aim of the TV programme, called Beeldenstorm in Dutch, is to inspire viewers who have either never been to a museum or no longer visit them, to become museum-goers. When you consider the growing pressure of commercialization, it's little short of a miracle that for more than ten years this programme has been a continuing success, going out at peak viewing time, once a week. Since 2000, art from museums outside Holland has also been included.

It can hardly be a coincidence that all the people with whom I collaborated on this project had a similar background. We were brought up to believe that it is a moral obligation to share the cultural heritage of our Dutch entrepreneurial society with those who haven't had access to it so far. In Holland this is an important concept in art education as well as in government policy. In summer 2000, together with Neil McGregor, then director of London's National Gallery, I took part in a seminar for recent graduates in art history that was held in Munich, Germany. It was titled Museums for Whom? Only then did I come to

understand how fundamentally different the ideological points of departure are in various western European countries on the subject of art education.

According to Neil McGregor it is a sine qua non of the British democratic tradition that art is for everyone. The museum where he worked was founded in 1831 with a subsidy from the British parliament, so that everyone who couldn't afford to own works of art themselves could still enjoy looking at pictures. Shortly after the Gallery's opening, a questionnaire was presented to the London population to find out who was going to the museum and who wasn't. When it appeared that turn-out was low among barbers, a campaign was immediately launched to make museums more attractive for hairdressers and moustache-trimmers.

Not only did people try to speak the same language as the barbers, they also made an effort to find out what might particularly appeal to them in the paintings of the masters.

The French approach the matter from a different angle. There the barbers have to learn the language of the elite. So the 'education of the eye' can only take place under certain strictly defined conditions, and certainly not in a flippant or light-hearted way. I should say straight away that art education in Holland may appear to them to be a somewhat frivolous undertaking rather than a deeply serious activity. On the whole, younger people are enthusiastic about this and recognize the innovative possibilities of a not-too-scholarly approach. They seem to understand that we are trying to appreciate art through the experiential world of the viewer rather than by asking what an art historian would think was important that people should know.

In many talks with young art historians this conflict between the two approaches to art often emerged: the stately and serious versus the frivolous and possibly flippant. It is a matter of the contrast between what someone is required to know, and what someone would like to know. But maybe it's unnecessary to talk about a conflict. What it's really all about is how far the expert is prepared to look at art through the eyes of a layperson. When we were discussing the TV programmes, a deciding factor in whether or not we would make a certain programme and what it would be like was what would interest the non-expert,

the general public. Indeed, it is not uncommon for me to ask lay-people for their ideas on choosing topics, and their opinions help to shape my approach. In these TV programmes and in this book, I emerge as someone who likes one work of art and doesn't like another one, who finds one approach interesting and another dull or commonplace. Art history offers no more, and no less, than a set of tools to enhance one's enjoyment of art. 'Art does not exist for the benefit of art history': the saying of the great art critic Meier-Graefe was chosen with good reason as the motto for this book. When he uttered this warning in Germany, the discipline of art history hardly existed in Holland. Perhaps it's easier for the Dutch to accept innovative approaches to art (as indicated by our TV programme's popularity) because Art History, as a respected academic study with a long tradition, is far less rooted in the Netherlands than it is in Germany. This brings me back to the idea of art as something that should be readily available for everyone, not just an esoteric or exotic interest of the cultured elite. Art is fun, art is life, art is wonder and delight, grief and confusion. Art is concentration on an object, taking time to examine its details and enjoy its presence. And the more stories you know about a picture, about its maker, the place where it came from, the people who owned it in the past, the journeys it has made – the richer and deeper your experience will be when you confront it.

Interestingly, over the past few years, Dutch paintings and the stories behind them – particularly those of the seventeenth century – have played a central role in several works of literary fiction. It would seem that Netherlandish art and the stories it engenders, is more popular than ever before. I very much hope that this book with its illustrations will delight you and inspire you to visit the museums that presently house the pictures and sculptures which I've described. And even if you don't make it out of your armchair, maybe you'll still have gained a new way of looking at art.

Henk van Os, Professor Art and Society at the University of Amsterdam, former director of the Rijksmuseum, Amsterdam

Minimal Beauty

There is a painting in Amsterdam's Stedelijk (Municipal) Museum, which is typical of the kind of modern art that prompts people to say, 'What on earth's that meant to be? There's nothing to see.' (fig. 1) That's true, there is *almost* nothing. But there is also an art to damping down the indignation and not delivering a prompt and scathing judgment. It's often rewarding to take the time to look more closely at a work of art, to wonder what exactly that 'almost nothing' really is.

This painting dates from 1958 and is the work of the Italian Lucio Fontana. He made it in the heyday of action painting (just slosh the paint on the canvas, the messier the better). In the Netherlands the CoBrA group was in full swing painting bright and busy pictures. So this painting by Fontana is a complete contrast – a daring statement about the minimal. This doesn't in itself make his work interesting, but it certainly provides a context.

Looking at Fontana's painting, we are struck by the loving care with which it is made (fig. 2). It shows, like many other paintings by him in European museums of modern art, the meticulous absorption with which he prepared his canvases. The ground painting is flawless, and this contributes greatly to the powerful effect of the work. Indeed, it is produced with that striving after perfection that characterizes Italian artists down the centuries.

But the flawless beauty of the painted canvas is immediately violated. For it has been violently slashed. At first sight, the jabs look as if someone overcome with fury has attacked the canvas with a sharp knife. This makes an immediate association with the concept of time, for unlike many traditional paintings, this doesn't look as if it occurred after a considerable space of time, but happened within a very short period. Which is precisely what the artist intended. He wanted his paintings to suggest links with a momentary, and in this case aggressive, action.

Fontana gave the same name to almost all his paintings, including this one in the Stedelijk Museum. He called them *Concetto Spaziale*, meaning something like 'a spatial notion'. The title suggests that the artist had another intention in mind with his work, beyond that of evoking a sense of time. The slashes in the canvas open it up so that the space behind the painting is in a way connected with the space in front of it. Thus, the flat surface of the canvas becomes a kind of screen which, because of the tears, forces you to become aware of the surrounding space. Musing over the idea, you realize how in this way Fontana has adopted an attitude vis-à-vis the artists who preceded him.

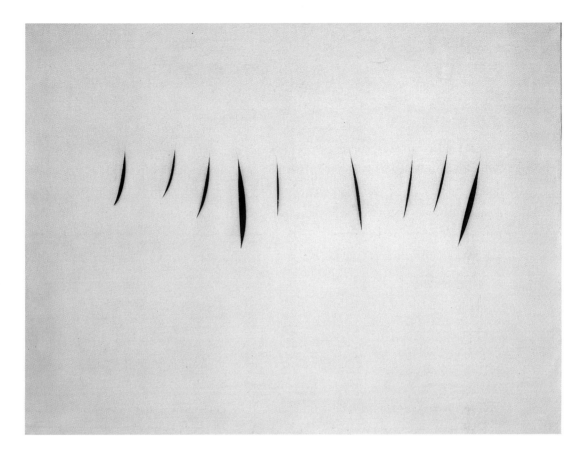

1 Lucio Fontana, *Concetto Spaziale Attese*, 1959, ink on canvas,
Stedelijk Museum, Amsterdam.

They employed perspective and other tricks of perception to suggest a sense of space and dimension on their flat canvases. Fontana actually works with space.

There is another earlier painting by Fontana in the Stedelijk (fig. 3). The canvas has several rows of holes and one row with pieces of red coloured glass. Ranged neatly in vertical lines upon the flat surface, the holes and pieces of glass combine to form a connected composition. Presumably this effect ceased to satisfy the artist after a while; instead of wanting to, as it were, scatter the viewers' attention, he wished to concentrate it upon one thing. As time

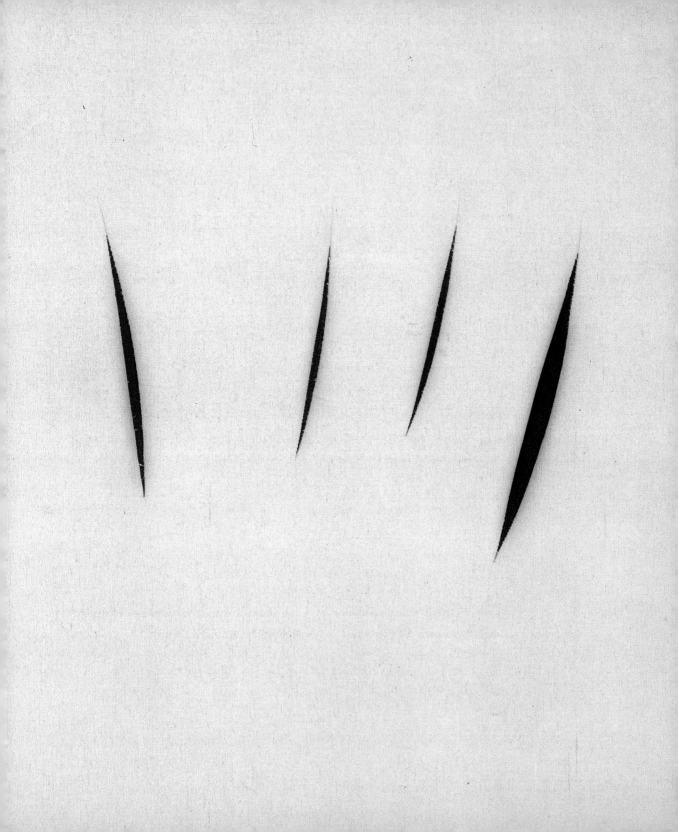

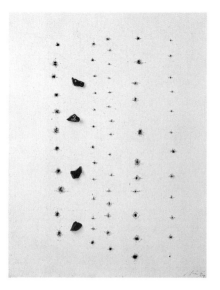

3 Lucio Fontana, *Concetto Spaziale*, 1953, latex paint and glass
on canvas, Stedelijk Museum, Amsterdam.

passed, his work became increasingly simple, and he was concerned above all that it should not be 'pretty'. He didn't quite succeed in that aim. For above all, Fontana's canvases remain attractive, highly refined paintings. Their little slits might suggest vaginas and subjects quite different from spatial representations, were it not for their title which keeps you in an abstract world.

The sculpture park in Otterlo's Kröller-Müller Museum also has some works, by Fontana (fig. 4). At first glance, it is hard to believe that these comical droppings lying upon the grass were made by the same person as the two cool paintings in the Stedelijk. Yet they bear the same name – *Concetto spaziale*. Unlike the flat canvases whose slits open up the space around them, these three-dimensional bronze spheres already occupy the space. So it looks as if in this instance Fontana wished to accentuate the feeling of space with the shapes he constructed and the way he arranged them.

2 The canvas is meticulously prepared, and the slashes in it
are precisely planned and placed.

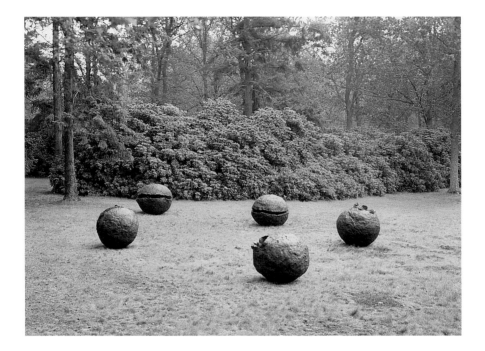

4 Lucio Fontana, *Concetto Spaziale Nature*, 1959-60, bronze
balls, Kröller-Müller Museum, Otterlo.

Fontana's canvases are in the first place monuments to civilization, superb paintings. In contrast, his bronze balls – especially when seen from a distance – resemble pieces of excrement dropped casually by some passing animal. Or perhaps they are giant green peas, cannoned out of their pods. They certainly suggest some form of natural life.

Curiously, they also reveal similarities with the paintings (fig. 5). The spherical forms have been hand-modelled with intense care. The modelling speaks of the same meticulous attention to the materials used as we find in Fontana's paintings. Furthermore, like the paintings, the balls display splits and openings whose edges are shaped with the utmost refinement. It isn't difficult to imagine the artist scooping and delving into a lumpy mass, forcing an opening in its solidity.

Everything would seem to indicate that when he was making these bronze balls Fontana, as at other times, was fully in control of what he was

creating. They are remarkably plastic shapes which you should come and look at in different lights, at various times of the day. As the sunlight falls upon them, the surfaces acquire everchanging textures. The slits and hollows create a relief-like structure, and as the sun moves across the sky, the forms gain constantly shifting accents.

Lucio Fontana's work is by no means repetitive. But it does have a consistency. You discover this when you take the time to look quietly. And then you also find how beautiful something minimal can be, the delight of that which is 'almost nothing'.

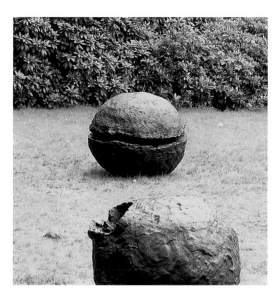

5 Both the ball itself as well as the edge of the slit show how the material has been worked.

Civic Guards and Football Teams

Look inside many a boy's bedroom and you're likely to see the walls plastered from floor to ceiling with photos of football teams (fig. 1). You know the kind I mean – clubhouses and football cafés hang full of them.

Sometimes that's all you can see on the walls, and it's an extremely dull sight. Why do the players have to sit in a straight row looking ahead as if they're mesmerized? Probably so that they'll all look the same – a sort of photographic democracy. Football supporters need to recognize their idols straight away, without being distracted by the other players in the vicinity. As a result, every photo of a sports team shows the same dull collection of indistinguishable figures.

In the Frans Hals Museum in the city of Haarlem near Amsterdam, there is a painting of a group of civic guardsmen on which the Dutch artist Frans de Grebber started working around 1516 (fig. 2). It's just like one of those uninteresting photos of a football team. All you can say for it is that the heads have a kind of gawky charm that makes the painting somewhat more palatable than those pictures of football heroes. On the left, a crowd of militiamen is squashed in behind a table. Above their heads is a kind of wooden partition, with yet more heads peering over it. The right side of the painting shows the VIPs – to judge from the more luxurious clothing of these gentleman and the fact that they're allowed more space to breathe in. They're altogether a splendid sight with their frills and ruffs, but the way they are arranged, like their fellows on the other side, also appears to lack structure. No one has taken the trouble to stage-manage this picture. Apparently, the painter didn't think about this either. And the clients certainly weren't worried – as long their heads could be clearly seen.

A question of faces – the earliest paintings showing militiamen, so-called Civic Guard Pieces, are simply row upon row of repetitive portraits. But while De Grebber was working away on his large canvas, along came Frans Hals with something new. A revised formula for the genre 'Civic Guard Piece' (fig. 3). It should in all fairness be added that Frans Hals had a somewhat easier task – he could leave out the hoi polloi and was only required to paint the bigwigs. His work, whatever the reason, represented a revolution in the artist's approach. Unlike so many of his predecessors, Frans Hals saw the large group portrait as an artistic challenge. He tried to give individual characteristics to each figure in the painting while at the same time forging a unity of composition that would be interesting to look at.

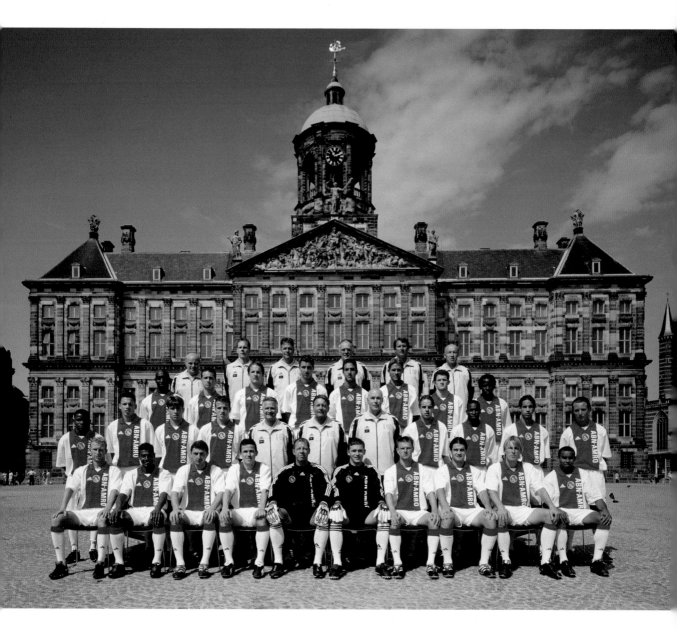

1 A row of cardboard figures, indistinguishable from
each other.

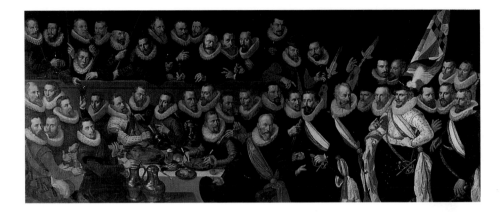

2 Frans Pieterszoon de Grebber, *The Officers and Sub-officers
 of the Haarlem Civic Guard Enjoying a Meal*, 1619, oil on
 canvas, Frans Hals Museum, Haarlem.

To appreciate how clever Frans Hals was, we need to look closely at how he structured his paintings. To begin with, he created a sense of depth, by placing his figures in front of and behind a table. Then he introduced something to link the otherwise disconnected heads. On the left, he strung them out along a diagonal line ending in the company's banner at the top centre of the picture. At first glance, the figures on the right, placed in front of and behind each other, appear to be less strictly organized. However, the diagonal lines produced by arms and sashes across the chest and ruffs are also closely interwoven.

Connecting the two halves of the picture is the ensign bearer. He directs us from one side of the painting to the other by looking emphatically over his shoulder. The direction of his gaze thus becomes a major element in the composition.

To underscore the unity within his scene, Hals has further made use of body posture and direction of gaze. In contrast to the picture by De Grebber, here the militiamen actually seem to be in touch with and reacting to each other. To the left of the ensign bearer, someone is telling a story to his neighbour, while the man seated as it were beneath the ensign takes a look at the large platter on the table, to which the bald man beside him is indicating. Right in the middle at the front of the picture, a man gazes out of the frame, cheerfully inspecting us, the spectators. Here is life, here is action, cunningly presented to us by an artist skilled in composition.

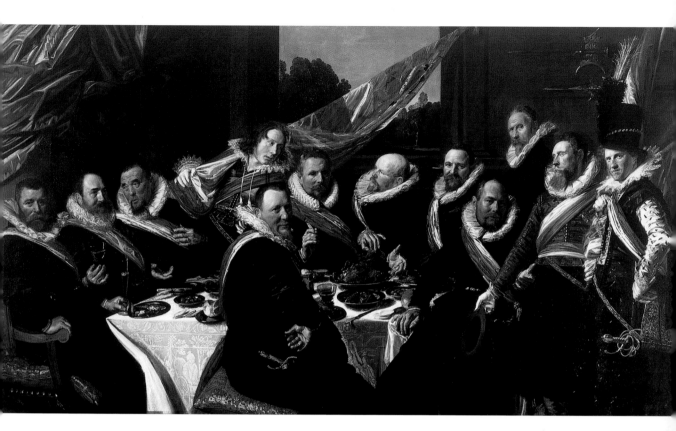

3 Frans Hals, *The Officers of the St George Militia*, Dining, 1616, oil on canvas, Frans Hals Museum, Haarlem.

It is chiefly Frans Hals's qualities as a designer that strike us in these Civic Guard Pieces, although he was of course also a masterly painter. There is a museum bearing his name in the city of Haarlem, close to Amsterdam, where you can study the development of these qualities in his art. There are four other Civic Guard Pieces by him in the museum. In 1627 he was again invited to immortalize these officers of the St George militia enjoying yet another festive meal (fig. 4). We notice straight away that the composition appears easier and smoother. Indeed, glance back at the earlier painting of this group, and the diagonal of heads seems somewhat stiff and awkward. Ten years had taught the artist to paint ever more freely, grouping his figures more loosely without this causing any sense of disorganization. Quite the reverse – the group forms a wondrous unity by means of subtle body movements,

hand and arm gestures, and angles of the head. The man on the left at the back beside the curtain, with his head bent to one side, cleverly draws the viewer's eye to the right-hand side of the group. And just look how the small man in the foreground on the right seems to reach out his hand, drawing us into his scene.

I can recommend everyone to take a trip to Haarlem and admire these paintings. They are so good that photographers and sports teams might well take the time to study them before the next season, and gain a little inspiration. What a splendid thing it would be if in future we were to find such ingeniously composed group portraits gracing the walls of cafés and clubhouses.

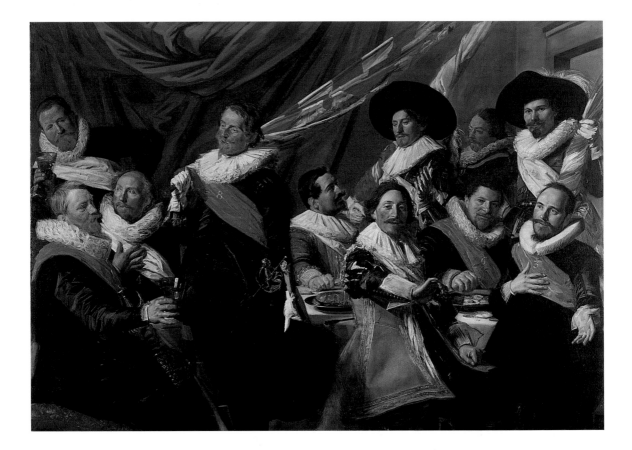

4 Frans Hals, *The Officers of the St George Militia*, Dining, 1627, oil on canvas, Frans Hals Museum, Haarlem.

Restoring a Self-Portrait by Jan Steen

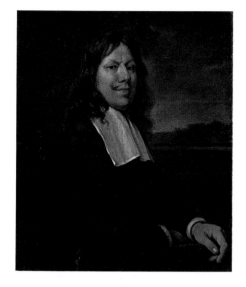

1 Jan Steen, *Self-Portrait* (before restoration),
c. 1670, oil on canvas, Rijksmuseum, Amsterdam.

This splendid self-portrait of Jan Steen can be admired in Amsterdam's Rijksmuseum (fig. 1). We recognize his plump cheerful face from other paintings in which he depicted himself, but there is a remarkable difference between this picture and the rest of the self-portraits he made. After all, Jan Steen is known as the profligate painter of racy scenes. Interestingly, a myth developed in as early as the seventeenth century to account for the supposed connection between this painter's life and work. In the picture shown here, Jan Steen has immortalized himself as a well-to-do gentleman, gazing directly and self-confidently at the spectator. We are shown an elegant refined figure, different than the one many artists were wont to present of themselves in their paintings. Indeed, this is precisely what makes this self-portrait so interesting.

If Jan Steen were to have his way, history would remember him – based on this portrait – as a dignified gentleman. The self-portrait suggests that even his profession of artist

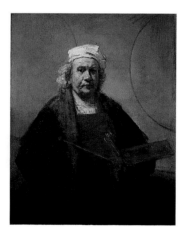

2 Rembrandt van Rijn, *Self-Portrait*, c. 1665, oil on canvas, Iveagh Bequest, Kenwood House, London.

didn't quite fit with the image of himself that he wished to project. In many contemporary self-portraits, the artist is seen with a palette – it is noteworthy that Steen shows neither easel, palette nor paintbrush (fig. 2). Instead, we behold a stately man of means, clearly no attic resident. And the fact that this fine figure had earned his money making paintings was apparently not what Jan Steen wished to show the public at large.

In the Jan Steen retrospective that opened in the Rijksmuseum in the autumn of 1996, this portrait was not to be seen. That is to say, not the way you see it here. Something curious had happened to the painting: down the left-hand side a wide dark stripe appeared to cover part of the artist's coiffure and his cloak or jacket. This was no way in which to appear at a grand exhibition in his honour. So the conservator Gwen Tauber took the painting in hand.

Even with the naked eye you could see something was wrong with the picture. But in order to restore the painting properly, more thorough study was needed. In restoration studios various types of expertise and technically complicated processes are used to investigate a painting's earlier condition. One such process is infrared reflectography, which photographs, as it were through the top layers of paint to show what lies below. When this process was used on the Jan Steen self-portrait, many exciting secrets were revealed.

On first sight the reflectogram, that is, the image that is 'photographed' using reflectography, appears very confusing (fig. 3). After a while your eyes begin to 'focus', and you recognize elements in the picture. You notice that the white collar worn by the smart gentleman was painted in various phases. Indeed, if you examine the work closely you can find three collars of different types. Steen evidently tried out various facial expressions when painting the mouth and eyes. With the successive trials the expression has gained in dignity and subtlety. At the same time, the roguish look gradually disappears.

The studies that were carried out on the painting revealed that considerable changes had been made both to the artist's figure and the background. It appeared that underneath the ugly dark stripe behind the artist there lurked a splendid draped curtain (fig. 4). This made all the difference to the appearance of the painter – now the red colour of the curtain provided a bright background instead of the depressing dark stripe. Another pleasant surprise was revealed when the landscape on the right of the picture was cleaned. From underneath the somber shapes emerged a rich and detailed rural scene.

In reaction to all this, an enthusiastically naïve voice might suggest: 'Away with all those superfluous coats of paint!' and indeed, some of them were removed. But it didn't seem wise

3 The infrared reflectogram shows the alterations that
 Jan Steen made when painting his face and shoulders.

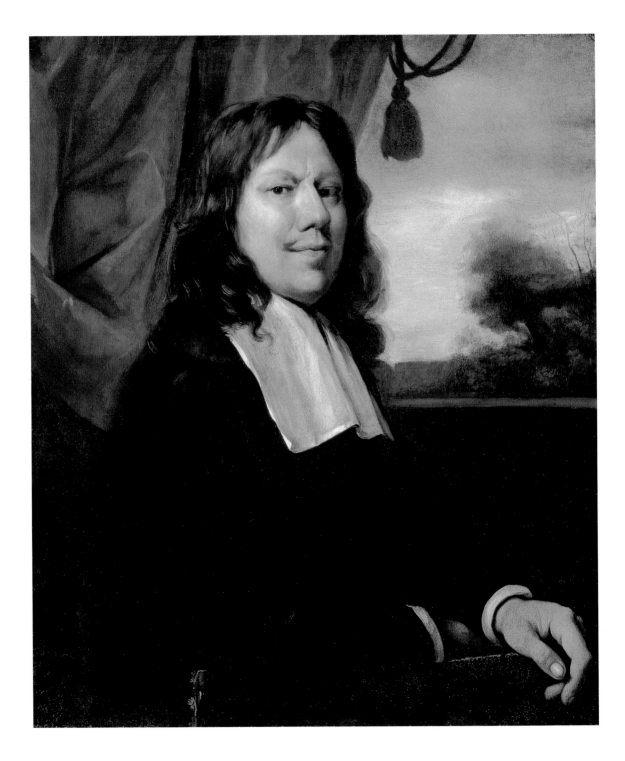

to be over-rigorous because you never know exactly who had applied another layer, or when. It is known that Jan Steen himself would often continue to alter details of a painting after it had been theoretically completed. Naturally, changes that the master himself had made to his painting, shouldn't be removed. And in this case it didn't seem wise to remove one of the later additions. When the dark stripe had been cleaned from the painting, what should appear at the edge of the curtain but an elegant cord and tassel. Probably this decorative element was added to the painting long after Jan Steen's death. But since nothing was painted beneath, it was decided after due consideration, to let the tassel remain. At this point, however, it was difficult for the painting restorer to decide exactly how to proceed.

Photographs of the underlying layers of paint demonstrate that this picture by Jan Steen is even more complicated than we have so far discussed. Steen's hand is resting on a balustrade that in fact becomes a kind of window-sill. This suggests that the interior as a whole would originally have appeared considerably roomier. Presumably the painter initially wished to present himself in an even grander setting than the one in which he appears today.

The many alterations and additions to this painting make it impossible for us to decide what exactly the artist originally had in mind for his picture. There seems a good chance that now, with the restoration completed, we are looking at the picture of Jan Steen as he saw it himself. Possibly, however, his definitive self-portrait still lies concealed beneath the coats of paint. Since there was no readymade solution to this puzzle, the conservator decided the best thing was to pause at the point she had reached.

One question still remains that I feel isn't asked often enough and which continues to intrigue me. Why should a picture like this be painted over again and again? Possibly because during its history it was more than once owned by an artist. The first such in this story is the eighteenth-century portraitist Hendrik Pothoven.

It is well-known that Pothoven was particularly fond of painting curtains complete with cords and tassels as a backdrop to his sitters. This might well account for the appearance of the cord and tassel in Jan Steen's portrait.

The second artist to own Steen's self-portrait for a while was a certain Charles Howard Hodges. Towards the close of the eighteenth century, he too took up portrait painting. But unlike Pothoven he preferred a neutral background (fig. 5). Thus, it is not altogether unlikely that Hodges stealthily removed the

4 When the painting was restored, much that had been hidden came to light, including the original background.

5 Charles Howard Hodges, *Self-Portrait*, c. 1825-30, oil on
canvas, Rijksmuseum, Amsterdam.

curtain in the picture of his renowned prede-
cessor by painting it over with a dark smudge.
All the better to focus on the artist's (facial)
features.

We cannot be sure exactly what took place, but
Jan Steen has certainly presented us with an
intriguing restoration problem. And despite all
our efforts so far, we have only half found a
solution.

The Last Prophet and a *Femme Fatale*

This small alabaster carving is to be seen in Maastricht's Bonnefanten Museum (fig. 1). Models of this type acquired the nickname of 'John the Baptist in disco'. This expression may suggest a swinging scene, but unfortunately it's just the opposite. To begin with, the figures look somewhat shabby and considerably weather-beaten. This is because they're carved from alabaster, which is a soft stone that quickly wears down. The features of the small figures have lost the sharpness they once had, and other subtle details have almost disappeared over time. At first glance, people often think this is a head with a halo around it – after all, in the fifteenth century saints and angels always had their aureoles. But in this case it's not a halo you're looking at, but a dish or charger. Upon which rests the severed head of John the Baptist.

John acquired his second name because he bap-tised people, among them Jesus Christ, in the river Jordan. Even before he did this, he had devoted his life to serving Christ and had prophesied his arrival, as the Messiah. The small sculpture has a picture of this in the upper section. John, looking down, points to the lamb whom he tenderly holds in the crook of his left arm. He made a famous pronounce-ment when he saw Jesus at the riverside, calling him the Lamb of God, or *Agnus Dei*. So saying, John prepared the way for the listening crowd to receive Christ as the Messiah, and at the same time as the innocent victim who would in due course be sacrificed to atone for the sins of the world. The death by crucifixion is thus prophesied at the very start of Christ's ministry. Thus, John may be seen as the last of the prophets. He was also to become a martyr, as his decapitated head reminds the viewer.

John the Baptist was imprisoned by King Herod, the tyrannical monarch of Judaea at the beginning of the Christian era. This was the same Herod who ordered the Massacre of the Innocents, when all the baby boys in Bethlehem were killed by the king's soldiers. The infant Jesus escaped with his parents to Egypt at this time. This was only one of Herod's atrocities. And as well as being a vicious tyrant he led an otherwise sinful life, breaking the Jewish laws. John the Baptist, in complete contrast, observed the laws faithfully and was furthermore an extremely courageous man.

Thus, when he was imprisoned by Herod, he didn't lose heart and beg for forgiveness. On the contrary – he spoke out against the sinful life of Herod and his Queen Herodias. 'You two,' he thundered, 'are committing adultery.' For the lady in question was already married to

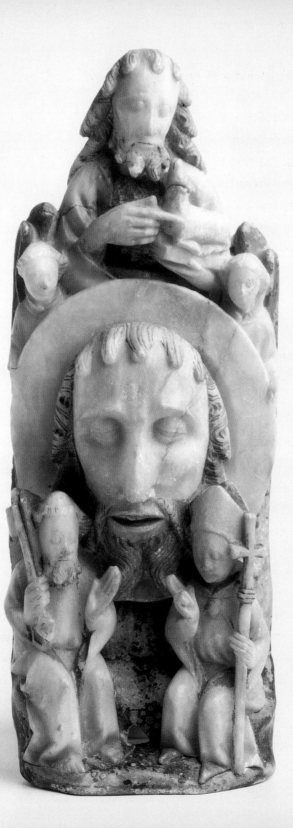

Herod's brother Philip. But she'd grown tired of her lawful spouse and pranced off with his brother the king. Which was a sinful thing to do, and not permitted according to the law. Such a relationship between brother- and sister-in-law was not excusable and constituted a serious moral offence.

Now the story becomes really spicy, because Herodias had a daughter from her former marriage, now a beautiful young woman called Salome. And although this really has nothing to do with John's disco, it so happened that she was a gold-medallist in belly dancing. At Herod's birthday party, with all the local dignitaries present, Salome performed for the guests and utterly charmed them with her erotic dancing. Herod was entranced and promised to give her a magnificent gift – so she popped off to consult mummy. Salome knew that her mother was being driven crazy by John's moralistic ranting, and she wasn't surprised when Herodias told her to ask for the Baptist's head to be brought to her on a large plate. And Salome, it appears, was a dutiful daughter. So she went back to Herod and told him the deal. And the king couldn't worm out of it, however much he would have liked to. John the Baptist was beheaded as Salome requested, and many medieval pictures show

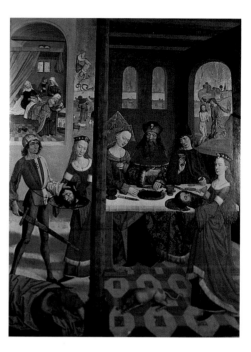

2 Medieval pictures often show Salome presenting the head of John the Baptist triumphantly to her mother and King Herod.

her presenting her prize to her mother in the presence of King Herod (fig. 2). Sometimes she is seen dancing before the company, bearing the head on a platter. But this alabaster statuette shows no such scene. Rather, it presents John as a martyr and a man to be respected. The two figures on either side of the Baptist's head add to the dignity of the scene. The apostle Peter sits at the lower left with his keys to the kingdom of Heaven, while to the right an anonymous bishop is seated. Their presence adds official status to the veneration of John the Baptist. It is as if the platter on which the head

1 Head of John the Baptist, Nottingham, late 15th century, alabaster, Bonnefanten Museum, Maastricht.

3 A triptych with the head of John the Baptist in the
 central panel, Nottingham, second half 15th century,
 Burrell Collection, Glasgow, Scotland.

lies is set upright with the approval of these two ecclesiastical dignitaries. Through this, the saint's head becomes an object for veneration. John the Baptist is revered in the first place because he heralded the coming of Christ the Messiah and his sacrificial death. Alabaster heads of this type generally formed the central section of a wood triptych to be placed upon an altar. A collection of these medieval objects in Glasgow, Scotland, shows precisely how the triptychs were put together (fig. 3). It was common for such small altarpieces to be used in private devotions. They inspired people to contemplate the life of John the Baptist and encouraged prayers for all sorts of blessings and cures. Apparently, John was a good saint to pray to if you suffered from headaches – the connection being, curiously, that he was beheaded. It is fascinating to think that the head of John

the Baptist has so stirred people's imaginations. Even more intriguing is how the New Testament story began to lead a life of its own in cultural history. It began with the figure of Salome who in the course of the nineteenth century gradually attracted more interest than the ascetic John. She came to represent the archetypal femme fatale, the embodiment of the seductive temptress. The sensual beauty of her body which she consciously accentuated, had turned the head of a king and thereby caused another man's head to roll.

Salome's story fired many a sculptor and painter to find their own manner of representing that mixture of pleasurable arousal and atrocious vindictiveness. The Salome fever reached its pitch around 1900. One of the most attractive paintings of her is by the German Franz von Stuck (fig. 4). The beautiful young woman appears to set the whole cosmos in motion with her magical dancing. Her pale skin emerges entrancingly from the dark starry sky behind. At her back a monster is descried in the shadows, bearing towards her, on a platter, the head of the unfortunate John.

Thus, we see that the story of John the Baptist has undergone a complete metamorphosis in the visual arts. It was originally intended to aid the veneration of the ascetic prophet. By the close of the nineteenth century, however, John has been demoted to figurant, and Salome holds centre stage. The biblical story serves

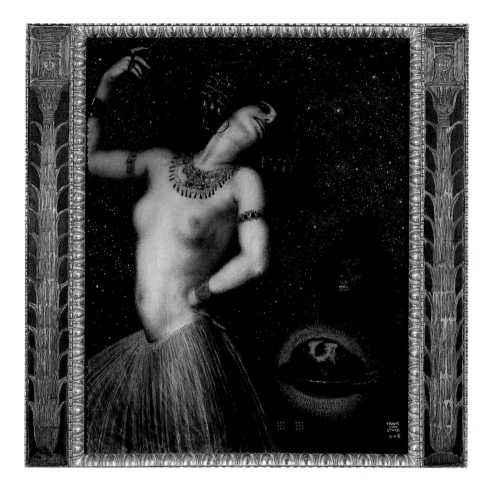

4 Franz von Stuck, *Salome*, 1906, oil on canvas,
Galerie im Lenbachhuis, Munich.

as a starting point for the representation of
the dire consequences of male lust and female
lasciviousness.

Pedestal Becomes Sculpture

In the rolling Dutch heathland in the east of the country, you will find the Kröller-Müller Museum, with its own sculpture garden, the oldest part of which consists of a large stretch of grass running down to a lake. It's a delightful place to walk around in and admire the artworks. Usually when you look at a statue, you don't notice that it's standing on something. Here all the sculptures have noteworthy pedestals. Socles come in all shapes and sizes, and the assortment in Kröller-Müller's park forms no exception. Here they all are, gathered together on the lawn, and it seems a fine opportunity to compare and contrast pedestals, rather than what they support.

One of the most venerable sculptures in this collection is by the French artist Auguste Rodin (1840 – 1917) (fig. 1). His *Crouching Woman* dates from 1882. The work has a strong dramatic impact, fascinating and appealing and at the same time mysterious. With their plasticity of form, Rodin's sculptures evoke intense emotions in the viewer, irrespective of the context. Rodin cast the socle for this sculpture together with the figure itself. Evidently, however, the socle was too small. If this crouching figure is to take her place in the wide expanse of grass, she needs some elevation. So she was raised upon another pedestal and now has a double base.

Nearby is a sculpture by the French artist Aristide Maillol (1861 – 1944) (fig. 2). This is placed on an extremely solid socle, which was most necessary, because the nude woman represented appears to float unattached in space. Not surprisingly, she is called 'Air'. It should be noted that despite her floating appearance, the allegorical lady looks fairly solid and well fed, indeed quite voluptuous. She reclines, as it were, upon an extended slab which appears to raise and separate her from the ground. So her figure seems almost to float against the green background of fir trees.

Once you really start looking at pedestals, you begin to notice how much variation there is in them. There's a sculpture by the Flemish artist Constant Permeke resting on a simple thin socle, that contrasts modestly with the massive base of Maillol's lady (fig. 3). The two sculptors wanted to express quite different ideas with their works. The female figure of the Flemish Expressionist represents Niobe. This queen of classical Antiquity had, so the story goes, a large number of children. She was extremely proud of having brought up such a nestful and indeed valued them more highly than the children of

1 Auguste Rodin, *Crouching Woman*, 1882, bronze, Kröller-Müller Museum, Otterlo.

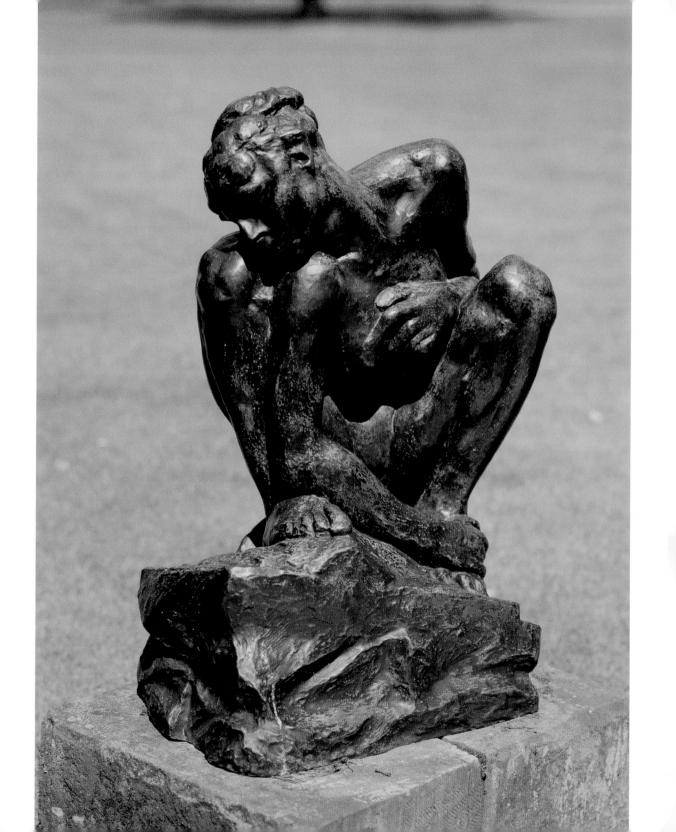

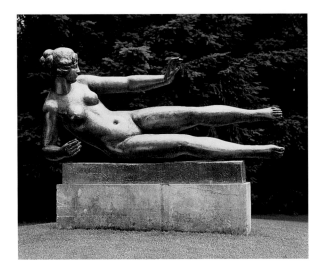

2 Aristide Maillol, *Air*, 1939, lead,
 Kröller-Müller Museum, Otterlo.

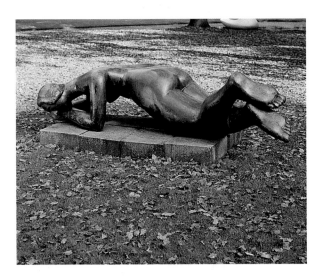

3 Constant Permeke, *Niobe*, 1951, bronze,
 Kröller-Müller Museum, Otterlo.

the gods. Now the Greeks have the word *hubris* to express the idea of human arrogance, or put simply, being too big for your boots. It inevitably leads to a sticky end. Niobe's punishment was that all her lovely children were killed. The artist shows her mourning upon her pedestal as if it were a tombstone. The next sculpture I want to look at has two abstract elements that seem to merge into one (fig. 4). The piece, called *The Couple*, by the Lithuanian-born American sculptor Jacques Lipschitz, demonstrates in a stylized manner the play of two interwoven bodies. This sculpture can't simply be placed upon the ground because if you look at it from above it resembles a dissected tortoise. The piece has to be raised a considerable distance from the ground. But the pedestal should not conflict with the lightness of Lipschitz's construction. The solution was to make a table-like construction especially for this work. Frankly, I find it one of the least satisfactory socles in this park. It looks a bit like a low stool for an intimate couple.

There are also some sculptures on the lawn that clearly don't need to be raised. One such is a work by the Italian Arturo Martini, titled *Judith and Holofernes* (fig. 5). The Book of Judith is one of the apocryphal Biblical stories recounting the victory of a strong woman over the not-so-intelligent male enemy. Judith managed to get into the tent of Holofernes, the enemy general, got him drunk, lulled him to sleep, and proceeded

to hack off his head. The statue shows Judith triumphant, with a serving maid holding the head aloft. Only the outlines of the bodies are indicated, so that the sculpture remains a solid block of stone, powerful, unsophisticated, unpolished. The sculptor set the figures on a shallow plinth, and here in the park they have a low pedestal of grassy turf. They remain close to the earth and the elements.

Surely the most popular work in the Kröller-Müller Museum park is Marta Pan's *Floating* *Sculpture* (fig. 6). Resting on the water, it moves gently to and fro in the wind and blends exquisitely with its surroundings. Naturally, it has no pedestal since it lies upon the water. But this small lake was specially constructed for the work. If you didn't know that, you'd think the water had been there a long time and inspired Marta Pan with the idea of the elegant abstract sculptural swan. In fact, it was the other way around, and in a manner of speaking the water provides the socle to the floating white art work.

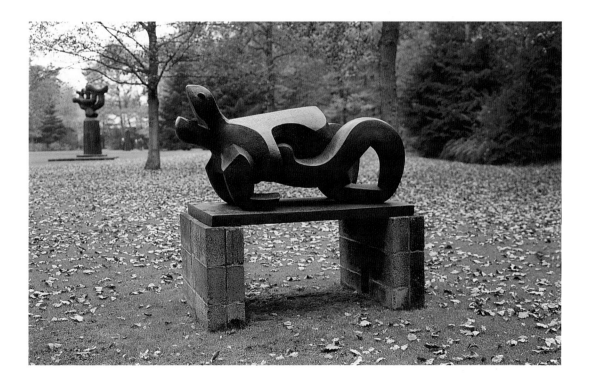

4 Chaim Jacob Lipschitz, *The Couple*, 1928-29, bronze, Kröller-Müller Museum, Otterlo.

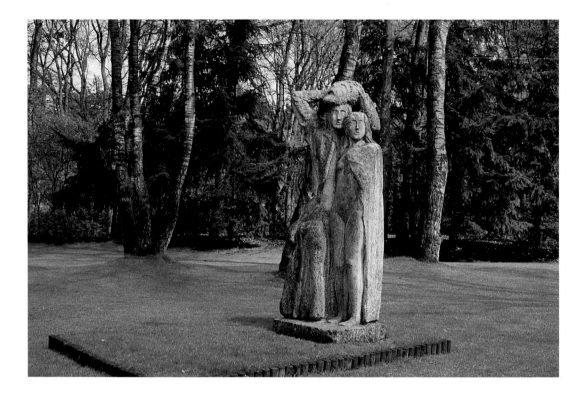

5 Arturo Martini, *Judith and Holofernes*, 1932-33, stone,
 Kröller-Müller Museum, Otterlo.

A new sculpture park was added on later beside the older one, and there we find a satisfying conclusion to this story of the museum's socles (fig. 7). For here the Scottish artist Ian Hamilton Finlay has turned the tables – pedestal becomes sculpture. Ingeniously, the artist has given this often overlooked aspect of a sculpture a whole new significance. The pedestals here call up memories of the past, in particular classical Antiquity. They look as if they are the bases of Greek or Roman pillars.

Names are inscribed in the socles, referring to figures from the French Revolution. Thus, the pedestal becomes a sculpture in its own right that stimulates you to think about certain past events, about that which is great and impressive, and about the meaning of sculpture.

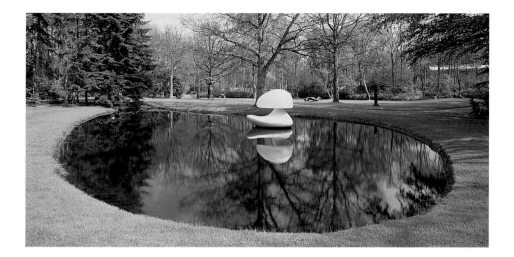

6 Marta Pan, *Floating sculpture 'Otterlo'*, 1960-61, polyester,
Kröller-Müller Museum, Otterlo.

7 Ian Hamilton Finlay, *Five Columns for the Kröller-Müller; or a*
Fifth Column for the Kröller-Müller; or Corot Saint-Jus,
1980-82, installation with five stone socles,
Kröller-Müller Museum, Otterlo.

A Haarlem Notable Disguised as Hercules

1 When he was making the series about works of art for
 Dutch TV, Henk van Os was invited to pose as a muscle man
 (he is adamant that this isn't what he really looks like).

In summertime, the Dutch beaches are some-
times adorned with painted wooden construc-
tions. You stand behind them, put your head
through the hole provided and have your photo
taken. There you are, dressed as a fisherman, or
in the local costume, or as a historical figure.
Often a comical sight. When making the TV
series about Dutch paintings, I was invited to
pose as a muscle man – not my usual line of
business! (fig. 1). Through the centuries, works
of art have been made that in a way adopt a
similar approach – a person poses as if they
were someone else. One of the most bizarre
examples of this identity change is a painting
in the Frans Halsmuseum in Haarlem.
This impressive canvas was painted by no-one
less than the famous Haarlem master,
Hendrick Goltzius (1558 – 1617) (fig. 2). The
picture immortalizes one of the city's notables,
Mr Colterman, transformed for the occasion
into the figure of Hercules. Clearly, the face is a
genuine portrait. However, this picture differs
in an essential detail from those seaside scenes.
Goltzius did not, as it were, place Mr
Colterman's head upon an idealized body of
the Greek hero. On the contrary – this Hercules
has the somewhat solid shape of a middle-aged
man of means. It's not hard to imagine how the
sitting would have gone. Colterman arrives and
Goltzius says, 'Well, if you would just get

2 Hendrick Goltzius, *Hercules and Cacus*, 1613,
 oil on canvas, Frans Hals Museum, Haarlem
 (on loan, Mauritshuis, The Hague).

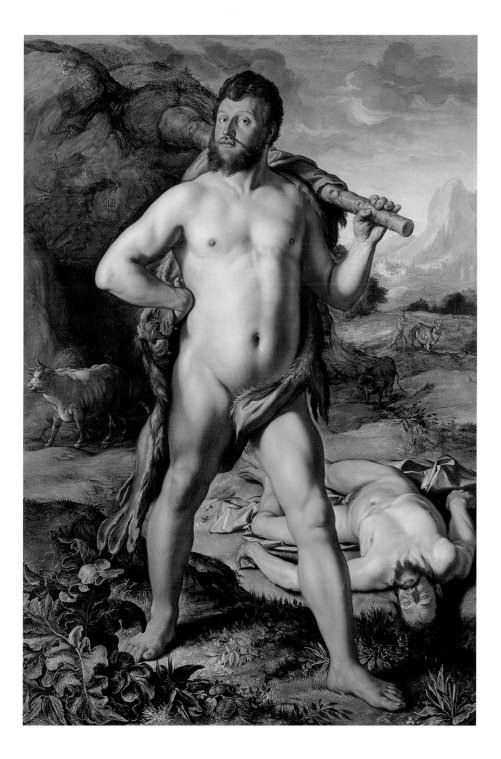

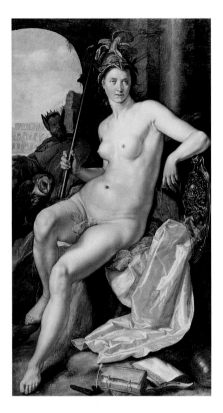

3 Hendrick Goltzius, *Minerva*, 1611, oil on canvas,
 Frans Hals Museum, Haarlem (on loan, Mauritshuis,
 The Hague).

painted the animal with amazing realism. But this was an aspect of his craftsmanship that occasionally served him ill. For apparently he was unable to idealize what he was painting – he recorded exactly what he saw. So this painting shows a plump Mr Colterman undressed, and not the face of the dignitary with the body of a Greek hero.

The canvas forms part of a painted triptych, all three pictures being by Goltzius. The two side pieces are considerably narrower but virtually the same height. Hanging in the same museum, they represent two deities from classical Antiquity. One is Minerva, or Athena, seen as a splendid and beautiful nude (fig. 3). She was the goddess of wisdom and martial strategy, which is why she is shown wearing a helmet, leaning her arm upon a shield, with a spear in her right hand. Her intelligence is emphasized by the figure behind her in the painting. It is the foolish king Midas with his donkey's ears. In the far background the artist has painted a ruin resembling Rome's Coliseum, as evidence of his architectural awareness.

The other god is immediately recognizable from his winged helmet – it is Mercury, the messenger of the Olympic deities (fig. 4). He was also associated with honesty and truth. These characteristics are emphasized, just as in the painting of Minerva, by a contrasting figure. Half hidden in the shadow to the left of Mercury as we look at the picture is the shape of a woman with a

undressed, you can hang your clothes over there, here's a club for you to hold, and I'd like you to stand right here.'

Lying immediately behind the lead figure in the painting is the dead body of Cacus, a notorious cattle thief in classical mythology. Hercules, busy with his twelve immense labours, chanced to come across Cacus and executed him for his nefarious dealings. On the left you can see one of the cattle Cacus was so fond of. Goltzius has

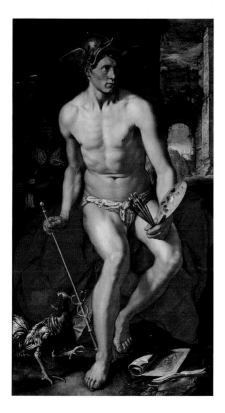

4 Hendrick Goltzius, *Mercury*, 1611, oil on canvas,
 Frans Hals Museum, Haarlem (on loan, Mauritshuis,
 The Hague).

magpie and a rattle. These items tell us that she is an incorrigible gossip who spreads lies and slander. Noteworthy here is the fact that Mercury holds a painter's palette and bunch of brushes in one hand. Goltzius is clearly drawing a link between the god and the artist's craft of representation.

Now you may ask, what the divinities Minerva and Mercury have to do with Mr Colterman. Although there is no pat explanation, an accept- able theory has been devised. Initially, the two paintings of the gods hung in Goltzius' work- shop. The artist wanted to make a good impres- sion on his clients when they visited him and advertise himself as an intellectual painter. When you entered his house you would say to yourself, 'Well, well, this is no tuppenny-half- penny dauber!'

Then one fine day Colterman, scion of a highly respected family of lawyers, came to visit Goltzius. In such distinguished circles it was all the fashion to proclaim your status via works of art. Colterman was delighted by the two Roman gods and thought they would be just the thing in his house. So he informed Goltzius that he'd like to buy the pair. Adding that there should be a third painting in similar style, representing himself, that would be suitable to hang between them. Goltzius accepted the commission.

When the third painting was completed, all three were transported to the Colterman resi- dence. This would undoubtedly have been a palatial building where the three large canvases would have seemed quite at home. But what I always quietly wonder is, 'What did Mrs Colterman think about her husband in the guise of Hercules?'

A Modern Master Dreaming of his Russian Roots

The figure in this painting has a curious and fascinating head (fig. 1). The penetrating eyes, curly locks and especially the strange painted angle in his cheek are intriguing. The features are strongly outlined, resembling edges that define distinct areas. The painting is a self-portrait of Marc Chagall (1887 – 1985), to be seen in Amsterdam's Stedelijk Museum along with two other works by this artist. They were all painted around 1912 at a fairly early stage in his career. Just at that time, modern art was appearing on all sides in Paris, where the Russian-born Chagall had been living for two years. So he witnessed the heyday of Cubism, the rise of Robert Delaunay's Orphism, or Orphic Cubism, and the earliest experiments in abstract art. In Chagall's work you can spot the influence of these movements, although he never officially joined any artistic group. He created a language of shape that was entirely his own, in which he made paintings telling about his identity and his roots.

At the top of this picture are two words in Hebrew characters, a reference to his Jewish background. They read, if you're facing the picture, 'Paris' on the left and 'Russia' on the right. A powerful summary of his present condition. He lived, he said of that time, with his back towards his place of present habitation and his face towards Vitebsk, the Russian town where he grew up. It is pictured at the upper right, inside a little cloud like a scene from a children's comic strip. Chagall often uses this kind of curious visual interpolation. It is as if he is presenting reality like fragments of a dream, associations and poetic imaginings. His paintings drift into our consciousness.

The self-portrait has another curious thing about it. Generally, when artists picture themselves before their easel, they are engaged in their work. Not so with Chagall. A finished piece stands on the easel, that tells of his recollections of Russia. He isn't painting, indeed, it looks far more as if he were engaged in exorcising the scene. With one hand he summons the picture onto the canvas. And we notice something unusual about that hand – it has seven fingers. In Jewish tradition seven is a special number, linked among other things to the seven days of the week. Possibly Chagall wished to state something about himself as an artist, to show himself as someone who creates, not just a run-of-the-mill *pentner*.

The second picture by Chagall in the Stedelijk

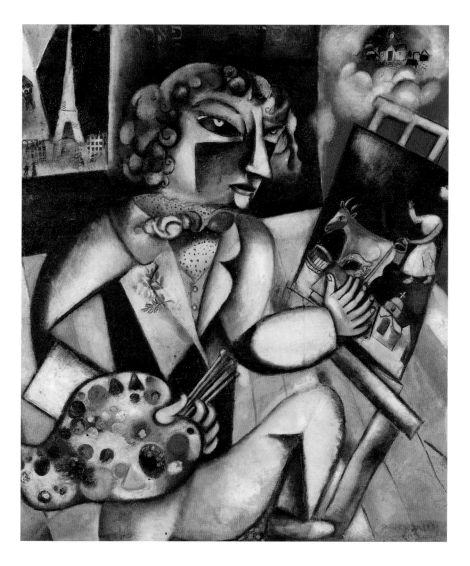

1 Marc Chagall, *Self-Portrait with Seven Fingers*, 1912-13,
 oil on canvas, Stedelijk Museum, Amsterdam.

also refers to his Russian roots (fig. 2). The
background colours of this tall painting have
the brightness and warmth found in many
Russian folk-artists' work. Against this brilliant
background stands the tall figure of a woman

who is evidently pregnant. At her waist the
flower-patterned skirt she wears has an oval
'window' inside which we see a homunculus.
This motif is undoubtedly taken from the icons
of Mary that Chagall would have seen in

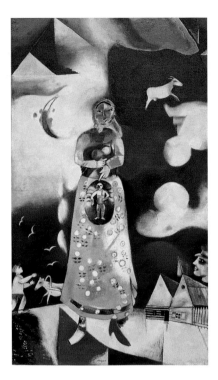

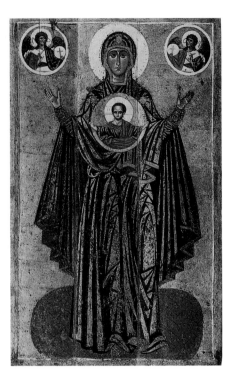

2 Marc Chagall, *Pregnancy/Motherhood*, 1913,
oil on canvas, Stedelijk Museum, Amsterdam.

3 It seems very likely that Chagall borrowed the motif
of the pregnant woman from a Russian icon like this.

Vitebsk (fig. 3). Here the Virgin is seen with widespread arms as if in prayer, while the figure of her son Christ can be seen through a circular 'window' above her waist. Such icons stem from the Byzantine tradition and are used when praying in particular to Mary and to Christ, the fruit of her womb. In this second painting we can also detect the influence of Cubism on Chagall. The woman's face changes mid-way and assumes a man's profile. This gives the picture another dimension, and it might very well be titled *Parenthood*, rather than *Motherhood*, as is presently the case.

A fascinating aspect of Chagall's work is how he gives added dimensions to his figures. In the painting of the pregnant woman, she appears not to have solid ground beneath her feet. She rises above the place where she lives. The farmer to her left reinforces this impression – for him, she is a vision floating in the air. The third painting by Chagall in Amsterdam that I want to discuss here contains yet another wondrous airborne figure as its central motif (fig. 4). We may assume that once again the artist has

delved into the Christian pictorial tradition when designing the composition around the main figure. For the violinist stands upon a circular segment which is bright green and gold. This type of disc is traditionally shown beneath scenes representing the saints. Thus, their ascension to heaven was visualized in a very explicit manner.

However, Chagall's cheerful fiddler looks as if he's here to stay for a while, and is drifting above his world in order to take a good look around. Behind the fiddler there are some characteristic views of Vitebsk – solid wooden houses whose roofs are thick with snow, two church towers, while in the foreground right a tree blossoms, and birds perch in it. This

mixture of seasons suggests that the artist wished to portray his birthplace in a timeless setting. It becomes a total picture, a memory in which the violin player literally provides the key. In the Jewish community in which Chagall grew up, all important occasions would be accompanied by music, led by the fiddler. Clearly, Amsterdam's Stedelijk Museum has three absolute masterpieces in these works by Chagall. They initially formed part of the important art collection belonging to the Regnault family. The collector from whom Regnault bought the works had acquired them in 1914 at an exhibition in Amsterdam. It would appear that due to the outbreak of World War I, the artist somehow never got paid. That's the way it often is with art masterpieces in the Netherlands. They delight us in a public museum, but they didn't get there because of shrewd policy: they arrived by sheer coincidence.

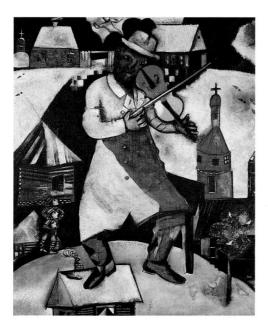

4 Marc Chagall, *The Fiddler*, 1912-13, oil on canvas, Stedelijk Museum, Amsterdam.

Enjoying 'False' Rembrandts

In the The Hague's Mauritshuis Museum there are several paintings that provide a good introduction to the 'Rembrandt question'. One of them is a large picture of *Saul and David* (fig. 1). The Old Testament tells the story of King Saul and his fits of uncontrollable rage. In order to soothe him, the young David would be sent for to come and play his harp before the king; music therapy has been well-known for centuries. However, this didn't always work. On one occasion Saul became so furious he threatened David with a spear; fortunately, he missed his mark. Even after this incident, David would often provide music for the king. In the painting Saul is seated, wearing an exotic turban, with the spear still in his hand – apparently reflecting. His other hand cannot be seen – he is wiping away his tears on the edge of a curtain.

This painting was formerly hailed as a Rembrandt masterpiece. It was considered to contain all the essential characteristics of the master's art. The artist had conveyed deep human emotion in an inimitable manner, using his familiar dark tones to reveal the fundamental themes of the story. But as it turns out, the painting is probably not by Rembrandt at all. The *peinture*, that is, the style and technique peculiar to an individual painter, has aspects that aren't found in known authentic works by the master. And so, almost 30 years ago, a well-known Rembrandt expert deleted this painting from the master's oeuvre. The then director of the Mauritshuis Museum was not amused. 'How dare you say that such a paragon of artistic profundity doesn't belong on the list, simply because of something as vague as the *peinture*? If Rembrandt didn't paint this piece, then who did?' His question remains unanswered, but it's presently widely accepted that this painting is not by Rembrandt.

Another painting in the Mauritshuis is, however, unequivocally by the master. This is a scene showing the Song of Simeon (fig. 2). In the New Testament it is told how, according to Jewish tradition, the infant Jesus was taken to the Temple in Jerusalem. Two old people were present on the occasion – Simeon and his wife Anna, who had spent their lives anticipating the coming of the Messiah. Not one of the Temple priests recognized the little child, but the aged Simeon did. Realizing immediately who Jesus was, he took the baby in his arms, looked up to heaven, and said to God: 'Mine eyes have beheld thy salvation.' The curious thing is that this work, undoubtedly by Rembrandt, has in the past received far less attention than more dubious works such as *Saul and David*.

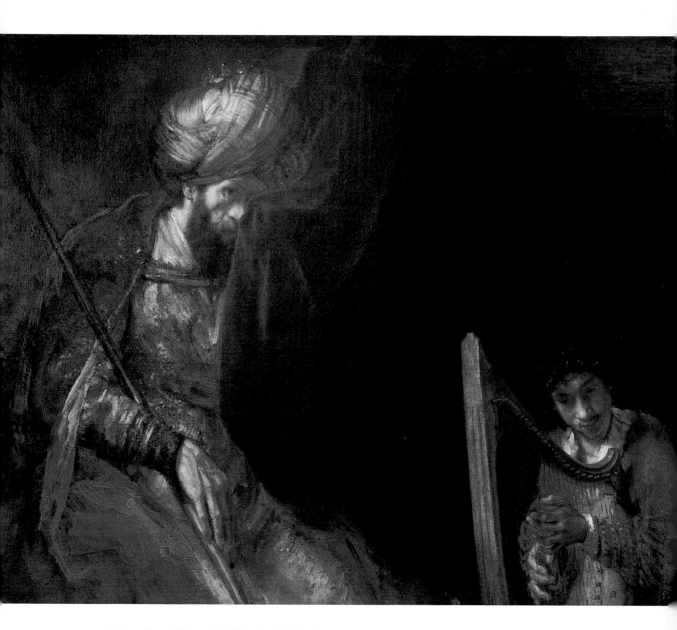

1 Rembrandt van Rijn (workshop?), *Saul and David*, c. 1650-55,
 oil on canvas, Mauritshuis, The Hague.

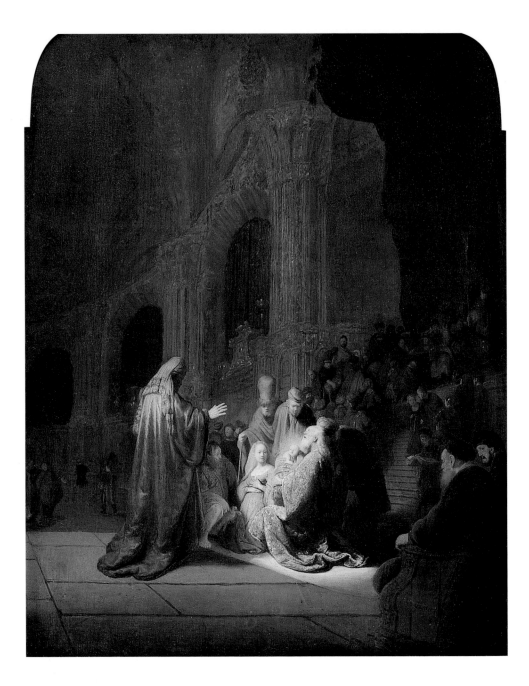

How can we account for this? When you think about it, you realize that *The Song of Simeon* does not have immediate emotional impact. The first thing we notice in the picture is the somber setting of the Temple, then we observe that it's filled with a crowd of people. Only after a general orientation does the central scene begin to emerge and speak to the imagination. In order to highlight this main theme so that it isn't crowded out by all the details, Rembrandt devised something like stage spotlights, shining them on the main emotional attraction. All things considered, his composition is cleverly managed, according to the then accepted artistic rules.

In the eighteenth century art critics were chiefly concerned with the qualities of paintings such as this one by Rembrandt. Indeed, for a long time such carefully composed early works by the master were more highly valued than his later, more powerful and pithy pieces. Not until the nineteenth century, influenced by the Romantic movement, did people start appreciating scenes showing powerful human emotions. Then the notion developed that such a tragic scene showing Saul see-sawing between rage and sorrow could only have come from Rembrandt's hand.

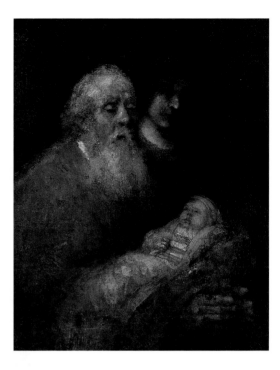

3 Rembrandt van Rijn, *The Song of Simeon*, c. 1661-69, oil on canvas, National Museum, Stockholm.

At the close of his life, Rembrandt again painted the Song of Simeon. This painting – presently in Stockholm – is as deeply moving as the picture of Saul (fig. 3). Compared with the early picture in the Mauritshuis on the same theme, this later work looks as if the painter has zoomed in on his subject. Simeon holds the infant Jesus in his arms, and we see little more than his head and shoulders, while in the background the only figure is that of a shadowy Anna. This is the Rembrandt all Dutch children know from their schooldays, thanks to the Romantic movement. The artist of the dark, muted tones, the thick

2 Rembrandt van Rijn, *The Song of Simeon*, 1631, oil on panel, Mauritshuis, The Hague.

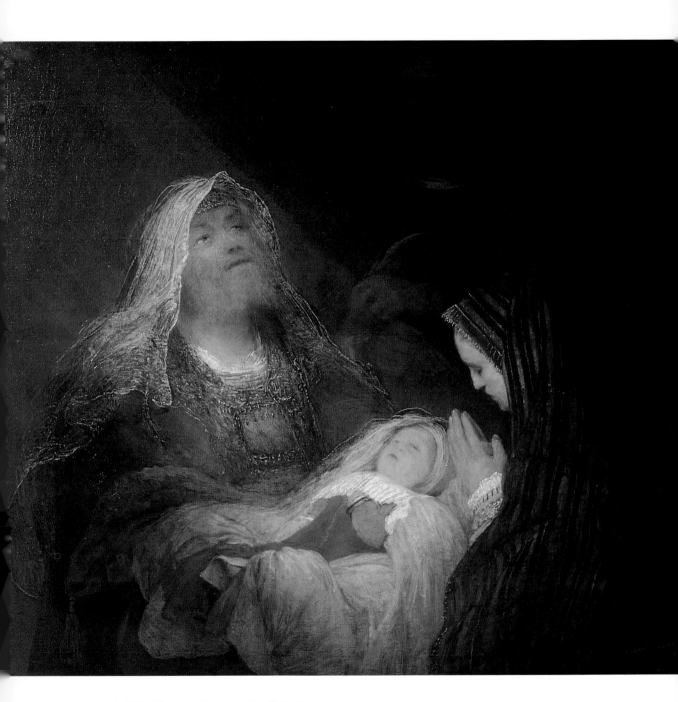

4 Aert de Gelder, *The Song of Simeon*, c. 1700, oil on canvas,
 Mauritshuis, The Hague.

paint, and the portrayal of deeply felt emotions. Finally, there is also a remarkably beautiful picture of the Song of Simeon in the Mauritshuis Museum (fig. 4). It isn't by Rembrandt but by his last pupil, Aert de Gelder, who lived until 1727. Inspired by the later work of his master, Aert went on painting in this style into the eighteenth century. This picture was made around 1700, based on Rembrandt's unfinished portrait of Simeon. Here too, the old man is shown as a half-figure, the picture focussing on the child held in his arms. De Gelder has accentuated and deepened the emotional content of the scene by adding the figure of Mary in the foreground, deep in prayer. The shadowy shape of Joseph is faintly suggested in the dim background.

Looking at this painting, it becomes clear that the 'Rembrandt question' is not in fact a question of quality. Each one of the three pieces in the Mauritshuis is superbly painted despite arguable differences in the *peinture*. Each scene has undeniably great qualities that bring the viewer intense enjoyment. To enjoy a work of art, you don't have to know who made it – master or pupil, celebrated or obscure.

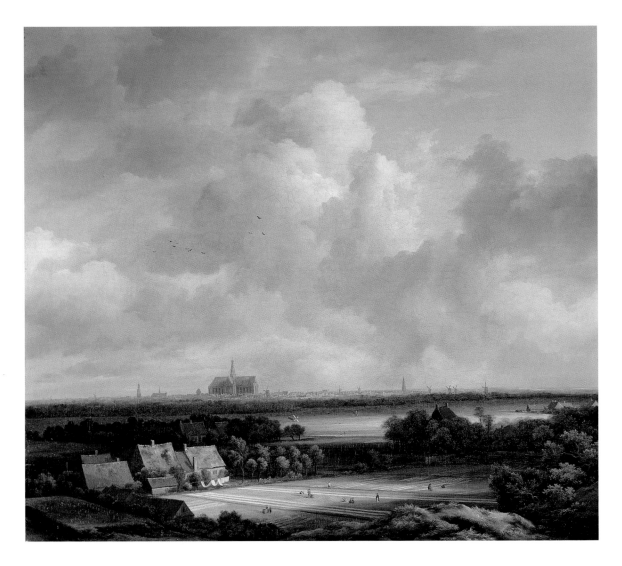

1 Jacob van Ruisdael, *View of Haarlem with the Bleaching Fields*,
 c. 1670-75, oil on canvas, Mauritshuis, The Hague.

Various Views on a Low Horizon

The Mauritshuis art museum in The Hague contains a splendid painting from around 1670 by the Dutch master Jacob van Ruisdael, titled *View of Haarlem* (fig. 1). The artist had gone for a walk in the countryside just outside Haarlem and, climbing to the top of one of the sand dunes, had glanced back towards the skyline of his native city. Towering into the clouds was the great cathedral of St Bavo. Looking at the picture today, the eye travels over the fields in the foreground, some sun-drenched, some deeply shadowed, where long swathes of woven linen lie stretched out, bleaching in the light. Ruisdael was an expert in suggesting depth by means of a low horizon.

Looking at this painting, it's hardly necessary to ask why the artist made it: the picture speaks for itself. After the city of Haarlem had been liberated from Spanish occupation in the sixteenth century, the citizens developed a strong sense of local pride. This extended beyond the city walls to the surrounding countryside. In the early seventeenth century the master mapmaker and engraver Claes Jansz Visscher (1586/7-1652) made a number of prints showing notable locations at the city's edge (fig. 2). This series of etchings was published under the title *Plaisante Plaetsen* (Pleasant Places) and directed especially towards the industrious citizens of Haarlem.

For if life was too busy to actually take a little walk and enjoy your environs at first hand, you could make do by leafing through the book in the quiet of your home and so pride yourself on the local beauty spots.

In this light it's easy to understand why Ruisdael's painting of a *View of Haarlem* was immensely popular. Indeed, people were so enthusiastic about the picture that it was printed in a series. It became so well-known as almost to become an emblem of the city, and many Haarlemmers had it hanging in their homes. Today, there are still at least fifteen similar views of Haarlem by Ruisdael in circulation. In the same room where the painting by Ruisdael hangs, there is another landscape with a low horizon and a sumptuous cloud-filled sky (fig. 3). Painted by the seventeenth-century Amsterdammer Philips Koninck (1619-1688), it is a far larger canvas than that by Ruisdael. Clearly, scenes with a low horizon demand special qualities from an artist. After all, you don't leave yourself much narrative space – if you pushed the skyline a little higher, there would be considerably more room in which to offer interesting descriptive details. But evidently that's not what Koninck wanted to show us. We gaze out from a slight eminence across the vast level countryside. There is a busy fore-

2 Claes Jansz Visscher, *On the Road to Leiden* [from:
Plaesante Plaatsen (Pleasant Places)], c. 1612-13, etching,
Rijksprentenkabinet, Amsterdam.

ground showing a hunting party with falcons, an approaching coach and horses, small houses dotted around, an angler at the water's edge and just beyond him, two women washing clothes in the stream. How do you prevent the scene from losing interest as you look into the distance? And how do you contrive to present a convincing impression of depth without having any object rising above the horizon – for here there isn't even the customary church tower.

Artists have various methods of getting round these difficulties.

In the first place, Koninck used the light in an intelligent manner. There is a sunlight zone in the foreground, while a patch of clouds darkens the centre section, giving way to another bright area behind. A second element creating space is the river, snaking away into the distant flatlands. The winding sand track has a similar effect. Together, river and road interact in a

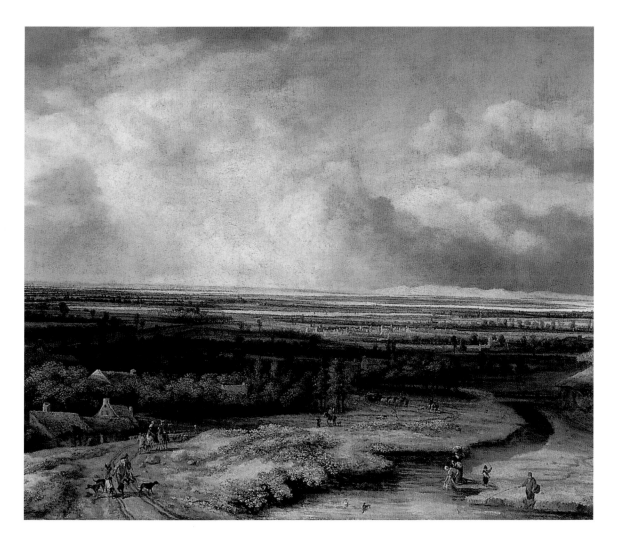

3 Philips Koninck, *Wide Landscape with a Falconry Party*,
 before 1674, oil on canvas, Mauritshuis, The Hague
 (on long-term loan from the National Gallery, London).

balanced dance. Finally, the figures contribute to the three-dimensional suggestion, their shapes growing ever smaller as they recede. The painter has employed many ingenious subtle tricks to draw us into the picture's space.

But you may ask yourself what exactly is he trying to achieve. In Ruisdael's case it was crystal clear: from a viewpoint in the Haarlem dunes, he looked proudly towards his native city. In Koninck's case we know nothing about

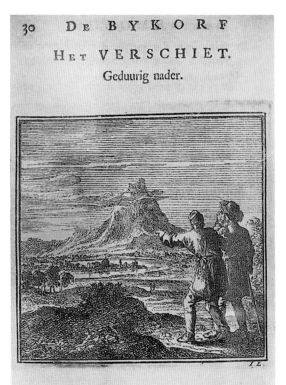

HEERE, maakt my bekend myn einde, en welke de maate myner dagen zy; dat ik weete, hoe verganke-lyk ik zy. Ziet, gy hebt myne dagen een hand breed ge-steld, en myn leeftyd is als niets voor u; immers is een ider mensche, [hoe] vast hy staat, enkel idelheid, Sela! Psalm XXXIX: 5, 6.

Hoe

4 Jan Luyken, *Distant Perspective* (from: *De Bykorf des Gemoeds*), 1711, etching, Amsterdam Historical Museum, Amsterdam.

his position, literally or metaphorically. Still less do we know today what was the precise significance for a seventeenth century viewer of such an open, seemingly unending, fantasy landscape. Koninck made a large number of this type of scene, which, broadly speaking, are very similar, although few rival the beauty of this masterpiece.

Several experts have puzzled over Koninck's work. One suggested interpretation considers seventeenth century emblem books. These contained educational pictures accompanied by an instructive poem to bring home a certain moral teaching. The seventeenth century Dutch lithographer Jan Luyken (1649-1712) made a picture accompanied by a short verse on the subject of distance and perspective, which at that time had a particular religious connotation (fig. 4). The text beneath Luyken's small etching begins with a quotation from the Psalms:

Lord, make me to know mine end and the measure of my days, what it is; that I may know how frail I am.

Reading this, you understand that a painted landscape doesn't necessarily have to represent an actual location or even an idealized setting. It may equally serve to illustrate a concept such as 'a sense of perspective'. Quite possibly, Koninck's scenes with their abnormally low horizons, just like Luyken's emblem book, were intended to help people put their lives into perspective. The viewer is reminded of life's

transience. In such a case, the horizon and the distance obviously contain a greater significance than the actual scene. This would certainly explain why Koninck's paintings never make it really clear from what vantage point you are looking. If this appealing though somewhat audacious interpretation is correct, the picture confronts you with the frailty of your own being.

Whatever the final explanation, it is a fascinating thought that two landscape paintings from the same period, with remarkable compositional similarities and hanging in the same museum room, should have been created with such utterly divergent motivation.

Comings and Goings of Two Musical Angels

In the Boijmans Van Beuningen Museum, Rotterdam, hangs a striking painting showing two angels (fig. 1). They are seated together playing musical instruments, one a small hand-held organ, the other a harp. They were painted in Florence in the early fifteenth century by an artist who bestowed loving care on the rendering of their clothing. If you look at the figures by other painters from this period, you'll notice they often appear somewhat flat and unrealistic.

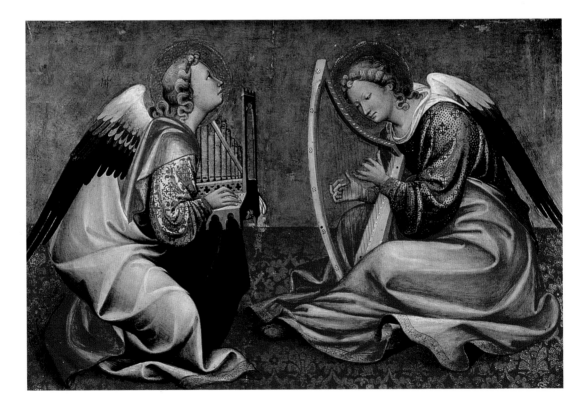

1 Gherardo Starnina, *Angels Making Music*, 1406, tempera on panel, Boijmans van Beuningen Museum, Rotterdam.

But the angels here are solid and alive, their elegantly draped robes suggesting rounded bodies beneath them. Indeed, with the brilliant light falling on the graceful folds of their garments, it's something like seeing a couple of swinging seraphim.

Looking at this cheerful scene, you don't realize at first that the panel once formed part of a far larger entity. Nowadays, we find angels charming to look at even on their own – think of that chubby pair painted by Raphael in the early sixteenth century (fig. 2). We may see them today adorning cigarette boxes, table mats, spectacle cases and napkins, but when they were first painted, people would hardly have understood this passion. Angels weren't isolated as decorative items – they always belonged in a scene. In the case of both pairs of angels we are considering here, the musicians and Raphael's, one of them is gazing deliberately upwards at something outside the picture. And if you pause to think about it, that swinging pair is presumably performing for someone's benefit.

In fact, the panel with the musical angels was once part of a large altarpiece. In the 1960s a German art historian reconstructed the entire work (fig. 3). That is, on paper, because the actual panels once comprising the work of art are scattered far and wide. The reconstruction shows the musical angels performing at the feet of an enthroned Madonna and Christ Child. Two more angels, one with a plucked, the other with a bowed instrument, complete the ensemble. All that remains of the Madonna and the angels beside her are the heads – respectively in Dresden's Gemäldegalerie and an English private collection.

The large central panel presenting the Madonna and the two pairs of angels was flanked on either side by two saints. The panel showing Mary Magdalene and St Lawrence – with the client who commissioned the altarpiece kneeling at his feet – has found its way to Berlin's Gemäldegalerie. The other panel, showing St Hugh of Lincoln and St Benedict, is presently in the National Museum of Stockholm.

The three panels that crowned the altarpiece, representing the Angel Gabriel, Christ with a hand raised in blessing, and Mary, are now in Frankfurt's Städelsches Kunstinstitut. And the narrative scenes decorating the predella, the base of the altarpiece, now enhance collections in Rome, Douai and Milan.

Hearing this range of European cities, you may well ask in growing astonishment – how on earth can one altarpiece become scattered in such a way? Whoever would take it into his head to chop up what is obviously one whole – and such an impressive work at that. It is even stranger that the fragments of the piece are exhibited in their various museums as if they were independent paintings with their individual stories, ignoring the fact that they were originally connected in one work. This

extraordinary state of affairs is best explained by recounting one piece of general history and one anecdote.

Initially, altarpieces weren't primarily regarded for their artistic merit but for their liturgical function. They were very much subject to fashion. The patrons who commissioned them desired increasingly to identify with the main characters in the story of Christ. A narrative scene packed with action spread across the entire width of the altar offered more scope than the static portraits of saints standing in a row. So, dynamic new altarpieces replaced the old ones, which were dumped in the sacristy. Dusty and forgotten, they remained there until the eighteenth century arrived, and art lovers gradually evinced a renewed interest in them.

This gave many a parish priest a bright idea. He could kill two birds with one stone – get rid of the fusty object that was only in the way, and make some money for his parish and himself. So if an interested tourist visited his church, looking as if his pockets were well-lined, the priest would inquire if perhaps the gentleman would care to take a piece of altar painting home for his collection. The pastor didn't sell the whole work in one go, but kept sections in the church in case of future rainy days. So it was that our altarpiece was sawn through the middle, and first the Madonna's head disappeared to foreign shores, followed by bits of her angelic chorus. Then came the turn of the saints to left and right, and finally the other panels. The painting in Boijmans Museum Rotterdam is thus something of a souvenir, but one made by an exceptional artist. His remarkable skills have already been mentioned. For many years it was held that the altarpiece of which the Rotterdam angels formed a section had been made in about 1423 for the Chapel of St Lawrence in the cathedral of Florence. The saint standing to the right of the Madonna was taken to be Zenobius, the city's first bishop. This, however, cannot be correct, since beneath his cloak the saint is wearing the habit of the Carthusian order, and Zenobius wasn't a Carthusian. Now it so happened that a Carthusian monastery just outside Florence had ordered an altarpiece for its chapel of St Lawrence about 20 years earlier. A Dutch art historian has argued most convincingly that the reconstructed altarpiece we are dealing with was made for that Carthusian monastery. Furthermore, based on the earlier dating and outstanding artistic quality of the piece, she concluded most compellingly that the painter in question was the famous artist Gherardo Starnina. The earliest known writer on art history, Giorgio Vasari, characterized Starnina as one of the most influential painters of the early fifteenth century. With his elegant dynamic style – acquired incidentally on a visit to Spain – he gave a new lease on life to the art world of Florence.

2 The pair of angels at the base of the Raphael Sistine
 Madonna are probably more often seen on their own than
 together with the rest of the painting.

3 The Rotterdam panel with the angels making music
originally formed part of a large altarpiece.

The musical angels in their delightful robes
decorating the wall in Rotterdam's museum
can certainly look back on a tempestuous past.
Initially worshipping the Virgin Mary, they
were later sawn from their setting, divorced
from their fellow figures, and disposed of like
second-hand jumble. The recent attribution has
now restored them to the distinctive place they
deserve in the history of Florentine art.

An Espionage Technique

During the Second World War the use of infrared cameras was developed, particularly in reconnaissance photography, to reveal objects that were not discernible visually. A method of detecting what the enemy was up to. A Dutch physicist, Van Asperen de Boer, developed a somewhat similar technique to assist art-historical research. Using a special camera, it's possible to make a type of infrared reflectogram showing what lies beneath the surface. Thus, the preparatory sketches now hidden by the top coat of paint or sections that have been painted over are exposed. An underdrawing can reveal a great deal of interesting detail about how an artist actually set to work. One of the first works to be examined using infrared reflectography was a panel, presently in the Hague's Mauritshuis Museum, by the medieval Flemish master, Rogier van der Weyden (fig. 1).

The painting, dating to the mid-fifteenth century, shows the lamentation over the dead Christ. His body has just been taken down from the Cross. Friends and family are grouped around, utterly crushed, gazing at his broken body. The panel originally formed part of an altarpiece. This seems most appropriate when you remember that during the Catholic Mass bread and wine are placed upon the altar and consecrated, whereby they become the body and blood of Christ. In this way members of the believing community take into themselves the essence of their God. Together with Christ's followers, Christian believers, in a spiritual sense, take down his body from the Cross and receive him into themselves. The bishop kneeling in the painting, presumably the person who commissioned this work, represents the world of ordinary people, in an otherwise holy and elevated company.

Thus, it was no problem to see what the painting was all about, but when people made a close study of it, another question presented itself and remained unanswered for a long time. In Madrid's Prado Art Museum there is a large altarpiece by Rogier van der Weyden depicting the Descent from the Cross (fig. 2). It is a most imposing work and superbly painted. In comparison, the panel in The Hague's Mauritshuis is less impressive from an artistic point of view. So some experts started to wonder whether this panel was in fact painted by Rogier himself – he never signed his work. The investigations carried out by Van Asperen de Boer have shed considerable light on this matter.

What do you see when you make an infrared reflectogram of a painting? The top layer of paint becomes a kind of blotchy surface, because the different colours allow different

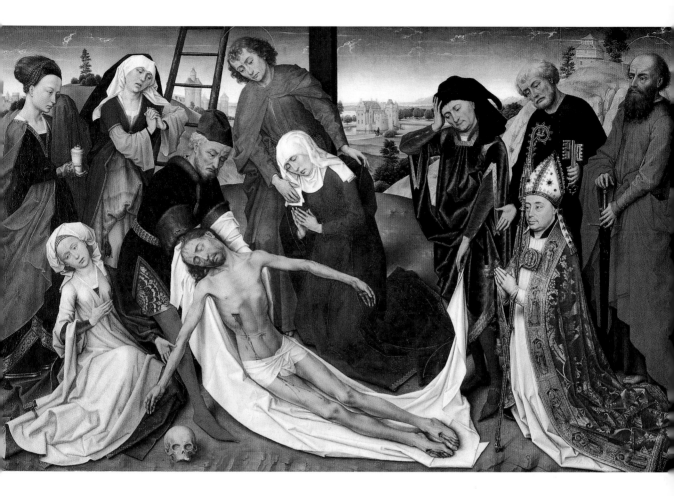

1 Rogier van der Weyden, *The Lamentation*, c. 1450,
 oil on panel, Mauritshuis, The Hague.

amounts of the light rays through. Some dark pigments appear solid. For the same reason, the black underdrawing becomes apparent. This is particularly interesting when it reveals what the artist originally intended and then overpainted. The panel in the Mauritshuis shows several intriguing alterations from Design One.

In the foreground left we see a skull, a refer- ence to Mount Golgotha, otherwise called the Place of the Skull, where the crucifixion took place. Initially, this spot in the painting con- tained a pot of precious ointment, attribute of Mary Magdalene (fig. 3). In the final version of the painting this pot of ointment can be seen in Mary's hands. She stands at the extreme left of the picture, robed in her traditional colour of

2 Rogier van der Weyden, *The Descent from the Cross*, c. 1440, oil on panel, Museo del Prado, Madrid.

scarlet. Strangely, she appears pensive and reserved, unlike her usual passionate representation. She is more often shown in an emotional state, like the woman kneeling here beside the skull – probably one of the three Marys.

It would seem that the artist wished to switch the accustomed roles. Thanks to the infrared reflectography we are able to follow him, as it were, at his work.

The same is true of the representation of Nicodemus, who stands beside the kneeling bishop, holding a corner of the winding sheet in one hand. In the New Testament the story is related of how he and the wealthy Joseph of Arimathea made preparations to place the body of Jesus in a cave. Here we see Nicodemus standing with one hand placed against his temple, somewhat thoughtfully; but in the underpainting his hand half covers his sorrowing face in a far more dramatic gesture (fig. 4).

Interestingly, in the final version of this painting, many of the emotions are reined in. The most passionate display is shown by the young woman who has sunk to the ground in the left-hand corner.

There is a third aspect of the picture that altered as the painter progressed: the position of Christ's feet. On the panel they lie stretched out parallel to each other. Such a presentation is fairly uncommon in Rogier van der Weyden's work. In other Lamentation scenes by him the feet fall pointing outwards. And it would seem

that was his original intention here, too (fig. 5). Apparently, however, he decided to try something different, and in the final version this was the position he chose.

When you examine all the reflectograms, you start to wonder what is the point of making such detailed preliminary sketches if in the long run you emerge with something looking quite different. This question touches the heart of the matter. An artist made an outline in the preliminary sketch, so that others could then paint in

3 In the spot where the artist decided to paint a skull, he had initially placed a pot of ointment used for embalming.

the details. The places where we find changes and alterations indicate that this principle has been waived. The master himself has been at work there, since it goes without saying that no one else was allowed to interfere with the original design.

The angular style of sketching that appears on all the reflectograms of the Mauritshuis panel demonstrates quite clearly a close connection with the underdrawings of the unequivocally

4 In the preparatory sketch the grieving Nicodemus is seen
 half-covering his face with his hand.

genuine altarpiece in Madrid. This means that at least the sections that have been changed in the Mauritshuis painting were done by Van der Weyden himself. But in contrast, the figures of Saints Peter and Paul, behind the kneeling bishop, appear somewhat stiff and stately and were most likely filled in by an assistant or apprentice.

Research into the materials and technical aspects of paintings is a fascinating business. But you need to make a note in the margin. Art historians and others like myself who aren't scientifically trained often cherish a quiet hope that scientists will be able to provide answers based on facts to all the problems that we cannot solve. It is a vain hope, because such developments as infrared reflectography provide illumination on certain points, only to introduce further complications on others. For example, how was the workshop of a medieval artist organized? And why did Rogier disrupt his normal pattern of painting, change the parts of the actors in the story, and restrain their emotions? In the end, physicists can do art history no greater service than to produce new questions, introducing an exciting new dimension to the field.

5 The painting shows the feet lying parallel, but in the underdrawing they are seen with each foot falling outwards.

Salvador Dalí's Rebus

Here I would like to deal with art and bizarre fantasies. The Rotterdam museum Boijmans Van Beuningen has a collage-painting by Salvador Dalí from 1939, which provides an ideal jumping-off point for this subject (fig. 1). It shows a kind of woman-monster, rather like the sphinx – but there's something unusual about the head. We recognize this face – Dalí cut out a photograph of the child film star Shirley Temple, who at the time was at the height of her fame making movies in Hollywood. He pasted the photo onto a piece of cardboard and then painted the body of a lion onto it. Crowning her head he set a bat with outstretched wings. It looks as if Mrs Sphinx has just completed a toothsome meal, for a quantity of bones and a couple of skulls lie scattered round about. In the distance the hulk of a stranded boat, now merely bare ribs, rests upon the sandy stretches. Immediately, we come up against one of the effects that makes Dalí's work so intriguing. He would often paint scenes with a high horizon so that the viewer gazes out over an endless, boundless open space.

A lot of people who aren't so keen on modern art can accept Dalí quite happily because at least you can see what his work represents. But a word of caution here! Because what in fact does this work represent? What has a sphinx got to do with Shirley Temple, and what's the meaning of the bat balancing on Shirley's head?

I suppose when people say they can see the meaning of Dalí's painting, they imply that there are bits they can recognize. But in this case the particular combination we see is pretty puzzling.

In the art of the nineteenth and twentieth centuries the sphinx was a symbol for the *femme fatale*, the seductive female who demolished everything and everyone. The scene then gains an extra dimension by allowing the sphinx to have the face of a known person. You make the association and conclude, 'That Shirley Temple, she was just another female harpy!' In the centre foreground of the picture is a small tag that reads 'Shirley!... at last in Technicolor,' which may allude to the fact that in 1939 the young film star had just made her first colour film. But possibly Dalí also wanted to say that it was he who had really (at last) given her some colour with his painting. It seems that the bat also had a special meaning for the artist. Once when he was young, he had found an injured bat lying on the ground, and when he went back in the evening to give it some food, the little creature had been almost completely devoured by ants. The story goes that Dalí, consumed with pity, then ate up the bat's head.

1 Salvador Dali, *Shirley Temple, the Youngest // Latest Film Idol
 of her Age*, 1939, gouache, pastel and collage on cardboard,
 Boijmans van Beuningen Museum, Rotterdam.

2 Salvador Dalí, *Couple with their Heads Full of Clouds*, 1936,
 oil on panel, Boijmans van Beuningen Museum, Rotterdam.

To tell the truth, I'm never quite sure what to do with rebus-like explanations of paintings. Do they really make a picture like this more understandable and more interesting? I prefer to keep my own associations with the sphinx, the bat and the boundless horizon.

The Shirley Temple picture isn't the only work by Dalí in the Boijmans Van Beuningen Museum. Their superb collection of surrealistic painters contains a few fine pieces by the Spanish master. Another of Dalí's works in the museum is interesting for a different reason (fig. 2). It's a very early example of what in art history came to be called 'shaped canvases' – that is, paintings that aren't simply rectangular but have been given a particular form. After World War II this became quite popular among artists, although generally the shape was the end in itself. In Dalí's case it was a marriage of shape and representation.

3 Jean-François Millet, *l'Angélus*, 1857-59, oil on canvas,
 Musée d'Orsay, Paris.

The silhouette of the frames tells you straight away that this is a double portrait – those in the know say it's Dalí and his wife Gala. And there begins the riddle: the expression 'one's head in the clouds' leads to all kinds of associations and interpretations. Furthermore, there is a model for the stances of the two figures, and that is the farmer and his wife in the nineteenth-century French artist Millet's *l'Angélus* (fig. 3). Knowing this adds a further layer to Dalí's picture.

Within the frames of the two heads, Dalí has painted two vast, open landscapes which, as it were, overlap and merge into each other. Each one has a table filling the foreground, a white tablecloth covering it and a few objects ranged on its surface – a kind of still life. Most intriguing is the bunch of grapes on the right-hand table. Its shape is mirrored by a tiny human figure lying in the distant sandy space. Experts say this figure represents Lenin.

595

Once again we find Dalí urging us to make cryptic interpretations while at the same time – and above all – he conjures with formal associations. In a most curious drawing of his, you see him transforming a similar bunch of grapes into all sorts of different shapes, ranging from a human figure to the rear end of a horse (fig. 4). That in fact is the enormous strength of this master of surrealism, not so much in the subconscious, psychoanalytical profundity. In his work, form and representation may suddenly blossom into something completely unexpected, thanks to his remarkable associative genius. This is why it often seems that you can understand Dalí's pictures at first glance. But not until you give your own imagination full rein do you begin to appreciate what these paintings are all about.

4 Salvador Dalí, Study for *Suburb of a Critical-Paranoid Metropolis*, 1935, ink on paper, Private Collection.

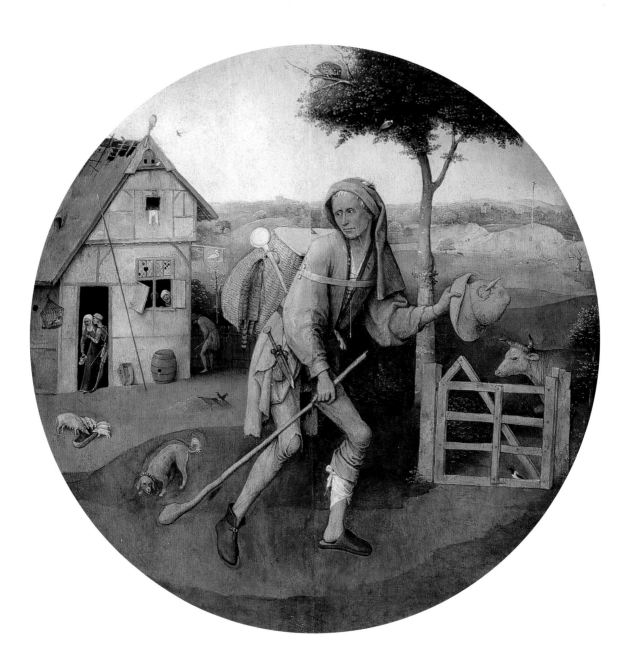

Prodigal Son or Significant Peddler?

Paintings by Jeroen Bosch are a rarity in the Netherlands. Rotterdam's Boijmans Van Beuningen Museum is the only one in the country where a number of works by the master can be found. The most striking of these is a picture of the Prodigal Son, the character who appears in one of the parables of Jesus. The painting will be familiar to most people under that title (fig. 1). However, recently the picture has acquired another name, to wit, The Peddler. I'd like to discuss the reasons behind this name change and how much it matters. What is the difference between a prodigal son and a peddler? The painting by Bosch shows a man wearing a shoe on one foot and slipper on the other trudging along in a somewhat awkward fashion. He is clothed in rags and tatters, giving him a beggarly appearance. Strapped onto his back is a large basket, indicating that he hawks goods for a living. A dilapidated house can be seen behind him, evidently a bordello. A couple appears in the doorway, locked in amorous embrace, while hanging from an upper window a man's underpants are clearly displayed. On the right, one of the presumed clients stands unabashedly pissing against the wall.

1 Jeroen Bosch, *The Prodigal Son/The Peddler*, c. 1510, oil on panel, Boijmans van Beuningen Museum, Rotterdam.

The message is quite clear: this is a house of ill repute. Indeed, the peddler casts a glance over his shoulder that suggests he has strong misgivings about the house and is going to hurry away from this unsavoury situation.

Granted this man looks very like a hawker, he nevertheless recalls the figure of the Prodigal Son in the New Testament story. The parable of Jesus recounts how a young man tells his wealthy father that he wants his share of the inheritance right away. His father gives it to him, and the lad promptly disappears to a distant land. There he squanders all he has been given, spending it – to coin a phrase – on wine, women and song. Inevitably, before long he hasn't a penny left and has to take a job looking after pigs in order to earn his keep. In this sorry situation he has time to reflect and decides to go home and ask his father to take him back. The father is overjoyed and – to the enormous jealousy of his brother who has sensibly remained at home being a good boy – hugs him warmly and forgives him.

With this story in mind, when we look at the Bosch painting, we see that it does have considerable Prodigal Son traits. The peddler too has turned his back upon a life of sin, but unlike the young man he has no flourishing future ahead of him. He is walking towards a gate

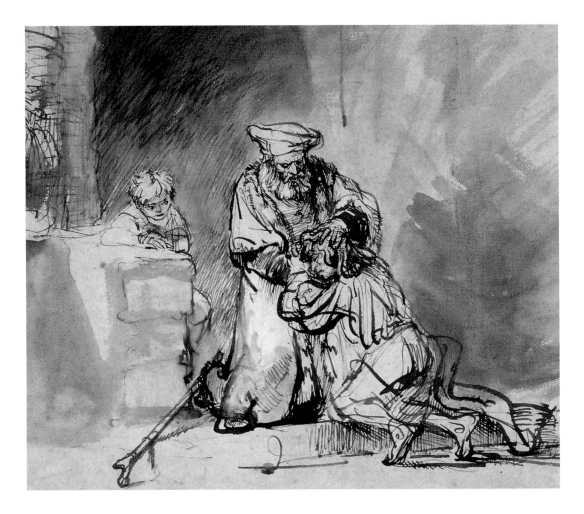

2 Rembrandt van Rijn, *Return of the Prodigal Son*, c. 1642,
drawing in pen and brush, Teylers Museum, Haarlem.

which is closed and on its lowest bar sits a
magpie, not a bird of good omen in late
medieval symbolism. On a hill in the distance
a tall stake rises from the ground, of the kind
on which criminals were impaled.

However, such unfortunate suggestions are
placed in the background, and our peddler in
fact stands quite far away from them. Indeed,
he fills the foreground, arresting and address-
ing our attention. He limps along despondently

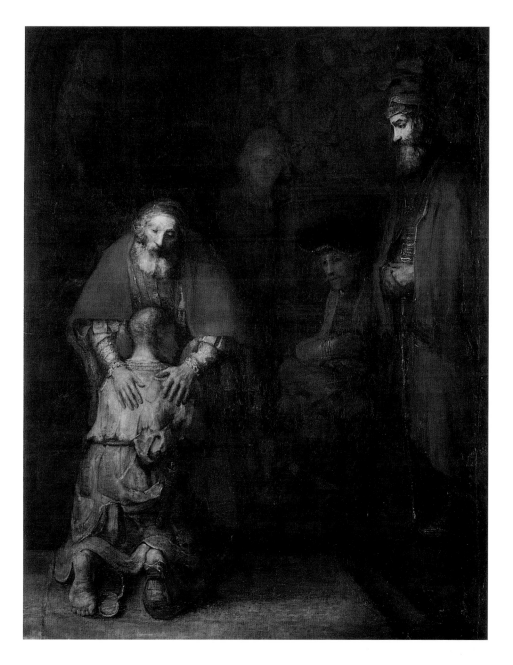

3 Rembrandt van Rijn, *Return of the Prodigal Son*, 1666-69,
 oil on canvas, Hermitage, St Petersburg.

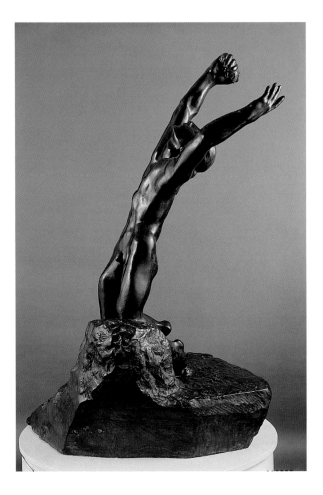

4 Auguste Rodin, *The Prodigal Son*, 1885-87, bronze, Musée Rodin, Paris.

associated with the biblical story of the Prodigal Son, for the theme was very popular in Dutch art. Far and away the most beautiful representations of the story are those of Rembrandt.

A drawing in Haarlem's Teylers Museum illustrates vividly the power of these pictures (fig. 2). Almost as if he had no choice in the matter, Rembrandt doesn't show a scene from the young man's 'riotous living' nor even from his miserable existence as swineherd, but focuses on the story's climax: the homecoming. In itself this isn't so remarkable – other artists had also depicted the moment of reconciliation. The difference was that generally both figures are shown standing, the son approaching from one side while the father waits to receive him. In Rembrandt's composition the dramatic quality of the scene is enormously enhanced.

Later, the master developed the picture even more. In a painting now in St Petersburg's Hermitage Museum, the son, with his back to the viewer, kneels before his father (fig. 3). The old man leans forward, arms around his child whom he had imagined lost forever, while the young man appears to bury his head within his father's embrace. This is the essence of the story: coming home and knowing you are safe and protected. Rembrandt's painting conveys this with timeless beauty and authority.

There is another moment in the story that also fills the hearer and viewer with emotion. In about 1900 the French sculptor August Rodin

bearing on his back a burden of sin. He appears anxious and careworn, arousing our sympathy and warning us not to begin on a life like his. So probably this is not the Prodigal Son but indeed a poor peddler, a lost soul, who would like to warn others away from his miserable life.

It isn't strange that Bosch's picture has been

made a large bronze of the Prodigal Son (fig. 4).
It is a solitary figure, isolated in despair and
loneliness, whereby Rodin emphasizes the
essence of the Prodigal Son: he has lost his way.
There is no copy of this sculpture in the
Netherlands, but one may be seen in the
Museum of Douai, close to the Dutch-Belgian
border.

Rodin's sculpture forms a splendid contrast to
Bosch's painting in Rotterdam. In the dramatic
gesture, arms uplifted, of the lonely boy, the
sculptor has captured his desolation. In Bosch's
work the hopelessness of the man is revealed
through the background which acts like a narra-
tive. His state of mind is illustrated by various
pictorial elements. And whether he happens
to represent the Prodigal Son or a significant
peddler is not really relevant, for we are gripped
by the human plight.

Rembrandt in his own Country – Not without Honour?

Every Dutch person who loves his or her country (even somewhat ambivalently) will tell you that Rembrandt is without doubt the greatest painter Holland has ever had. And everyone thinks that's how it's always been. Not so. It's true that Rembrandt never fell into total obscurity in the Netherlands, but the enthusiasm for his work did reach a very low ebb at one time. Not until the second half of the nineteenth century did his paintings start being appreciated once more. When the appreciation for an artist fluctuates considerably in one country, it usually happens that as a result of this declining interest much of his or her work is sold abroad. So it was that almost all of Rembrandt's paintings originally in the Netherlands emigrated to the domains of British lords, German nobles and French collectors. As late as 1850 the sizeable art collection of King Willem II of the Netherlands was auctioned. It contained a couple of impressive canvases by the Dutch national master. So when did Rembrandt's works actually begin to trickle back into his own country? The first painting to do so was bought in 1865 by the Boijmans Museum in Rotterdam from a Parisian art dealer (fig. 1).

It is an intricate picture, the title in old-sounding Dutch translating as *The Unity of the Nation*. Not a topic for breakfast chitchat. The picture is also curious in the way it is painted, being almost sketchy and using a limited range of colour. It is the kind of piece that an artist would make to show a client, with the question, 'Is this what your excellency had in mind?' And if the client answered, 'Yes', then the painting would be made, usually in considerably larger dimensions and a far richer palette. This canvas is a typical preliminary 'painted sketch'. The scene it presents is full of political references. Such pictures were generally implemented on huge canvases to be hung in monumental buildings.

Let us now investigate the ins and outs of this picture to discover what it all means. The lion seated on the left of centre is clearly a major figure. Presumably this is the lion symbolizing the Netherlands, and the bundle of arrows under his paw resembles the bundle of rods born by Roman senators, signifying that strength lies in unity. Apparently one of the Dutch provinces or cities was feeling a trifle rebellious in 1640, the date when the painting was made – which would account for the one arrow that doesn't lie neatly in the pile. So far,

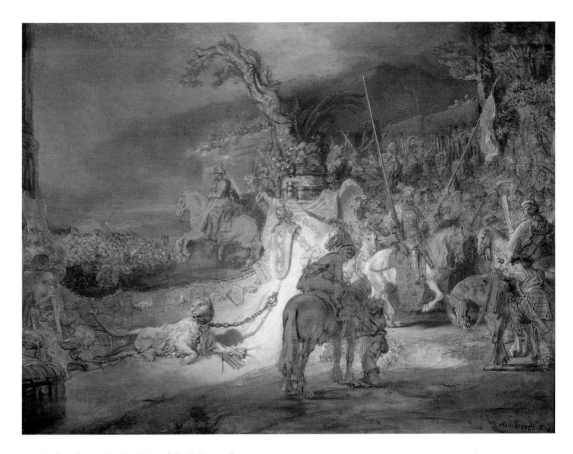

1 Rembrandt van Rijn, *The Unity of the Nation*, c. 1640,
 oil on panel, Boijmans van Beuningen Museum, Rotterdam.

the experts have been unable to decide which province or city this represents.

The lion lies sprawled out upon a kind of banner which also hangs behind him. The edge is adorned with the coats of arms of some of the Dutch cities and between these can be seen hands that grip each other. Within the circle of allied cities, the chief position is granted to Amsterdam. Beneath this city's dominating shield bearing the three crosses lies the chained lion, while just behind Amsterdam's coat of arms we see two wings, symbolizing victory. Above this there appear to grow two trees, an oak on the left, symbol of virtue and strength, and a palm tree on the right, whence the victor's wreath.

2 Rembrandt van Rijn, *The Anatomy Lesson Given by Dr Joan Deyman*,
1656, oil on canvas, Amsterdam Historical Museum, Amsterdam.

Sword in hand, Lady Justice stands on the lion's left behind a throne with a crown. Little by little we perceive the message of this painting. The unity of a nation can only exist if all the cities join hands; the fate of the lion is directly connected with this. It seems likely that the whole story is about inspiring the troops. These were possibly civic militiamen and maybe also the stadholder's army. Whatever the case, on the right of the picture there are soldiers marching as if to war, and in the background a battle is being waged.

Now we ask why this particular work was bought back for its native land in the nineteenth century. What caused the sudden Rembrandt veneration? Before 1830, when the Netherlands and Belgium still formed one kingdom, people thought of Peter Paul Rubens as the greatest Dutch painter. When Belgium became a separate kingdom, the Dutch lost not only part of their former territory but also their right to Rubens. But since Rembrandt already had a great name abroad, he was chosen as the successor and crowned the new artistic king of the Northern Netherlands. It is a fascinating thought that the first picture by him

to be bought back from foreign hands is so pre-eminently a Dutch political allegory. Considering the burgeoning interest in Rembrandt, it took quite some time before the next work by him came winging home. A good fifty years later, in 1882, the city of Amsterdam acquired *The Anatomy Lesson given by Dr Joan Deyman* (fig. 2). This fragment of a once far larger canvas hung until quite recently in the city's Rijksmuseum, before being transferred to the Amsterdam Historical Museum, where it can presently be seen. Around 1900, however, there were only nine genuine Rembrandts in the Netherlands. Not until the twentieth century did the recuperation process really take off. It is thanks to this – enormously expensive – operation that today we are able to gaze at the master's son Titus busy at his desk, side by side with *The Unity of the Nation* (fig. 3). And in Amsterdam's Rijksmuseum we can admire *Titus as a Monk* and *Rembrandt's Mother as the Prophetess Anna*. For the time being the last of the emigrants returned a few years ago with the splendid *Portrait of Johannes Uyttenbogaert*, now also to be admired in the Rijksmuseum. What can we learn from the seesaw story of Rembrandt appreciation in the Netherlands? That we shouldn't imagine all too glibly that an artist's fame endures through the centuries. The only one who has maintained his position through the ages, from the incense-filled medieval times until today, is the great Italian Renaissance master, Raphael. Even Michelangelo and Leonardo da Vinci have known periods of lesser fame. The development of Rembrandt's position in the Netherlands is not an unfamiliar story. In the mid-nineteenth century his star was very low in the firmament. Then he was rediscovered – and not for his artistic merit, but out of pure political necessity and at the suggestion of outsiders. So he became Holland's glory. It is thanks to this re-discovery that works by him such as *The Unity of the Nation* now hang in Dutch museums along with many of his other paintings.

3 Rembrandt van Rijn, *Titus at his Desk*, 1655, oil on canvas, Boijmans van Beuningen Museum, Rotterdam.

1 Maarten Corbijn, *Portrait of Henk van Os*, 1995.

Portrait and Image

A good portrait always shows more than the mere physical exterior. Above all, it reveals how a person would like to be seen by others. Just think about it. The minute someone appears with a camera you automatically straighten your clothes, pat your hair into shape, and set your features to appear engaging (fig. 1). After all, you want your picture to look attractive. And if the final result doesn't have the desired ambience, then the photo is a failure – at least, as far as you're concerned. In days of yore, people used to have themselves immortalized by painters. Then too, it was all a question of projecting a certain image, indeed, possibly more in former times than today. There are a fair number of portrait paintings in the Mauritshuis in

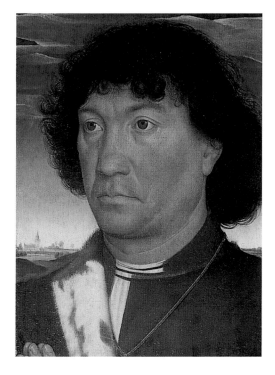

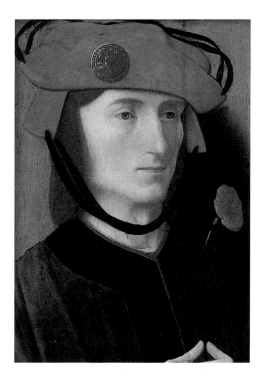

2 Hans Memling, *Portrait of a Man Praying with a Landscape in the Background*, c. 1480, oil on panel, Mauritshuis, The Hague.

3 Master of the Brandon portrait, *Portrait of a Man Holding a Carnation*, c. 1510-30, oil on panel, Mauritshuis, The Hague.

The Hague. One room contains splendid early examples from the fifteenth and sixteenth century. The most venerable one was painted around 1480 by the Flemish master Hans Memling (fig. 2).

When I see pictures like this, I inadvertently recall what we learned at school: the Renaissance led people to discover themselves as individuals. This burgeoning curiosity formed the start of a new phase in Western civilization. Memling tried to record the man's outward appearance with an almost fanatical accuracy. Every line in his face, every trace of stubble on his jaw, every single feature. But making a portrait isn't just a question of recording the outward appearance – as I've suggested, there's also the question of how a person wishes to be perceived. In the case of Memling's portrait, this is more than apparent. The man has his hands folded as in prayer, and his gaze isn't directed at the viewer but a little to one side. Originally there was a second panel there showing the Virgin, now presumably lost. Together the two panels formed a diptych. We gather that this man wished primarily to demonstrate his deep religious faith as well as showing what he looked like.

Close to this portrait hangs one of a slightly later period by an unknown artist (fig. 3).

However, it is clear from the style of the painting that its maker also came from Flanders. Here too, we see a man's face in subtle detail, but the presentation is softer, more shadowy. This man also, it would seem, had his portrait painted for a particular purpose. He looks to one side, holding a prominent red carnation. In the fifteenth and sixteenth century the carnation was the flower you offered to your true love. It seems highly likely that her portrait once formed the partner beside his. Both the portraits under discussion are missing their pendant pair, from which they would gain their true significance. But there is a major difference between the two pictures. The second, later, work does not represent the relationship between a human being and the divine, but rather that between two people. When you study these two panels you begin to wonder – when did the portrait become an independent genre in painting? When did people start being interested in images for their own sake, without cause or context? An impressive portrait by Hans Holbein the Younger, also in the Mauritshuis, records the moment when this happened (fig. 4).

Holbein was one of the first great artists who devoted himself to painting independent portraits. Before long, his fame had spread throughout Europe, and the notables of many countries wanted him to immortalize them on canvas. And rightly so. His work is remarkable

4 Hans Holbein the Younger, *Portrait of a Woman*, c. 1517, oil on panel, Mauritshuis, The Hague.

for the manner in which it captures the essential characteristics of an individual while at the same time projecting the strength of a large structure. There are few other painters in the sixteenth century who achieved this combination. The woman in Holbein's picture, subtly and delicately painted like so many of his works, creates the impression of someone who for a moment is absorbed in a cool inner silence. The portrait is pure poetry, due partly to her expression of dreamy composure. Although it seems most likely that this woman enjoyed the companionship of a husband – the portrait presumably once had a pendant – she appears in no way lacking. The artist presents her as a self-sufficient individual.

Most Dutch art museums have only a limited selection of works by non-Dutch artists. Indeed, the great masters are often poorly represented. In this respect Holbein forms an exception for the portrait gallery of the Mauritshuis contains various pieces by him. One of them is the masterly portrait of the Englishman Robert Cheseman, painted in 1533 (fig. 5). What is striking about this picture is the curious manner in which Cheseman is looking – like the pictures discussed earlier, his glance skirts past the viewer, but what is new is that he is clearly focussing on something in the distance. Against an almost undefined background he emerges sharply, demanding the viewer's full attention. Cheseman evidently instructed the painter not only to accentuate aspects of his individuality but also to indicate his honourable profession of falconer. So by using various attributes, the artist tells us of the Englishman's distinguished social position.

The early portraits in the Mauritshuis gallery are evidently not simply representations of what people looked like. The pictures also show how the sitters thought about themselves, in a secular or a spiritual sense. Made centuries ago and in a world utterly unlike ours today, these old pictures are in a way not so different from contemporary photographs. For when we pose and say 'cheese' we hope secretly that the finished result will show us as we'd like to be. The image is always what we permit others to see of our own reality.

Within the painting the inscriptions read:

· ROBERTVS CHESEMAN ·
ANNO · D M ·

· ETATIS · SVÆ · XLVIII
M · D · XXXIII ·

5 Hans Holbein the Younger, *Portrait of Robert Cheseman*, 1533,
 oil on panel, Mauritshuis, The Hague.

Origins of Sports Cups

1 In the main exhibition area of the Ajax Museum, you will
 find the Europa Cup I which the club won in 1995.

Nowadays, any organization with the slightest
ambition to create its own image will set up a
small museum recording its history. In the
Netherlands there are presently about eight
hundred such establishments, a staggering
number for such a small country. The

Amsterdam Football Club Ajax couldn't be left
behind and recently acquired their own museum,
housed in the new ArenA complex on the out-
skirts of the city. Entering the main exhibition
space you are confronted by an array of gleam-
ing cups and shields (fig. 1). Memories surge
back to moments of glory in the club's recent
past, tense football matches like the Champions
League final in 1995, ending in triumph. As
I survey the imposing contents of the showcase,
I am reminded of something quite different.
The shape of many of these dazzling cups and
beakers derives directly from the art of ancient
times.

In the Dutch city of Leiden there is a Museum
of Antiquities where you can see just how close
the connection is between the sports trophies of
long ago and those of today. The ancient Greeks
awarded winners of athletic contests by present-
ing them with a large vase. Team games like
football hadn't quite arrived at that time, but
individual sports such as wrestling and chariot
racing were hugely popular. And the winner
would be presented with a cup – known as an
amphora – often decorated with pictures illus-
trating the sport for which it had been awarded
(fig. 2). On the reverse of this particular cup is
the Greek goddess of wisdom and military strat-
egy, Pallas Athena, flanked by fighting cocks.

2 Panathenaic amphora, c. 530 BC, earthenware,
 National Museum of Antiquities, Leiden.

the gods and the rest could be sold for profit.
Clearly, since time immemorial, sport and
commerce have gone hand in hand.

There may be people who object to the above
comparison. Alright, they will say, maybe the
shape of the sports cup derives from ancient
Greek objects, but the huge handles adorning
the Europa Cup I clearly date to modern times.
Wrong! Here too, the designer has been
inspired by the earthenware pots of the ancient
world. In Leiden's Museum of Antiquities you
can see an Etruscan drinking cup dating to the
sixth century BC, known as a kantharos, which
has a deep bowl and two large handles, striking-
ly similar to those on the Europa Cup (fig. 3).
Just the thing to grasp the cup firmly before
drinking from it. Or indeed to hold as you raise
the cup to kiss it in delight, as winners of sports

On her shield is a panther attacking a deer. The
message is all too clear: already in those days,
sport had become warfare.

Although the sports awards of the past and
those of today have striking similarities, there
are also clear differences. Unlike the trophies
acquired by Ajax, the amphorae weren't made
of precious metal but of glazed earthenware.
Nor did their winners drink champagne from
them. They were filled with precious olive oil,
pressed from the harvest of particularly holy
orchards. Some of the oil would be offered to

3 Etruscan kantharos, 6th century BC, earthenware,
 National Museum of Antiquities, Leiden.

4 The Arol Cup moved to its permanent home in a showcase in the Ajax Museum after the club won the cup for the fifth time.

contests are wont to do, drunk with victory. There is something particularly elegant about this Europa Cup; it successfully combines two classical forms of pottery. This is less true of other goblets adorning the shelves of the Ajax Museum. Take the Arol Cup – it's great that Ajax won it, but I can't say it really appeals to me (fig. 4). Interestingly, this cup too has ancient forebears. The Greek hydria, a water jug, usually had three handles – two to lift it

with and one to hold while pouring. The Arol Cup has two handles identical to a water jug from the sixth century BC, now in the Leiden museum (fig. 5). And the scenes painted on this jug offer us a glimpse backstage, as it were, in the football stadium. We see two athletes taking a shower under a stream of water that spouts from a decorative faucet on the wall above them, adorned with animal heads. Others are rubbing oil into their skin, very likely prior to a delicious massage from the sport physiotherapist. To avoid any misunderstanding, I should perhaps make one thing perfectly clear: it is in no way exclusive to the football sector to turn to classical Antiquity for inspiration. In the history of the Western world, classical art has almost always been considered the gauge of supreme beauty. At the close of the eighteenth and beginning of the nineteenth century, the classical influence was strongly felt in all the arts. A splendid example of this is the work of the Wedgwood factory in Britain, producing pottery that in design and colour sometimes rivals pieces from Antiquity (fig. 6).

Although at first glance it might appear that the Ajax collection is slightly unusual, on closer examination we find it fits into an ancient artistic tradition. However, the supply of examples from the ancient past isn't a bottomless pit, and

5 Hydria, a water jug, showing a scene in the baths, c. 520 BC, earthenware, National Museum of Antiquities Leiden.

sometimes what emerges can be quite comical. In 1971 the sports clothing firm Adidas pronounced the Ajax football team to be European club of the year. They were awarded a trophy – modelled after the famous statue of the winged Greek goddess of victory, Nike. The sports mark bearing this name was presumably not yet a serious rival for Adidas, when they selected this particular prototype for their prize.

And while we're on the subject of names – it's not really surprising that the Ajax football club maintains ties with its classical heritage. After all, it takes its name from one of Homer's Greek heroes, a valiant figure in the Trojan war. The image of Ajax is part of the club's emblem, and you can admire his likeness all over the place in the club's museum. So in the classical mode, the next thing we may expect to see will be a Sparta Museum, for the Rotterdam football club of that name.

6 The design and colours of Wedgwood pottery often appear purer than those of vases from classical Antiquity.

Artists who are Engineers

There is a most remarkable collection of sketches by Leonardo da Vinci in England's Windsor Castle. They show that although he was an artist, he was primarily a scientific investigator who approached all natural processes and phenomena with boundless curiosity. He wanted to understand human anatomy and so dissected the bodies of executed criminals. He also calculated the turbulence in water and air currents and studied various types of weather conditions. One of his drawings in Windsor Castle shows an overcast sky with the threat of an imminent thunderstorm (fig. 1). The cumulus clouds and fall winds at the edge of the valley evidently fascinated Leonardo more than the need to provide a precise rendering of the location.

The great Italian master also made a drawing that will be familiar to many people. It shows a man standing within a circle and a square, fingers and feet touching the perimeters. His finely balanced position is accentuated by horizontals, verticals and diagonals. This is a study of the ideal proportions of the human figure. Since the time of Leonardo, countless artists have busied themselves with this. Such artists function like engineers.

In The Hague's Gemeentemuseum there are several works by people whom we can describe as 'scientific artists'. One of these paintings was

1 Leonardo da Vinci, *Storm*, c. 1506, red chalk on paper, Windsor Castle, England.

made by the German artist Josef Albers, in 1961 (fig. 2). During the 1920s Albers worked first as a student and then as a teacher at the famous Bauhaus, in Weimar and Dessau. The Bauhaus was a kind of experimental college where people were engaged in developing art which would have universal significance. Rational methods were conceived and used through which a great variety of works of art could be produced. These pieces would all be logically constructed so that

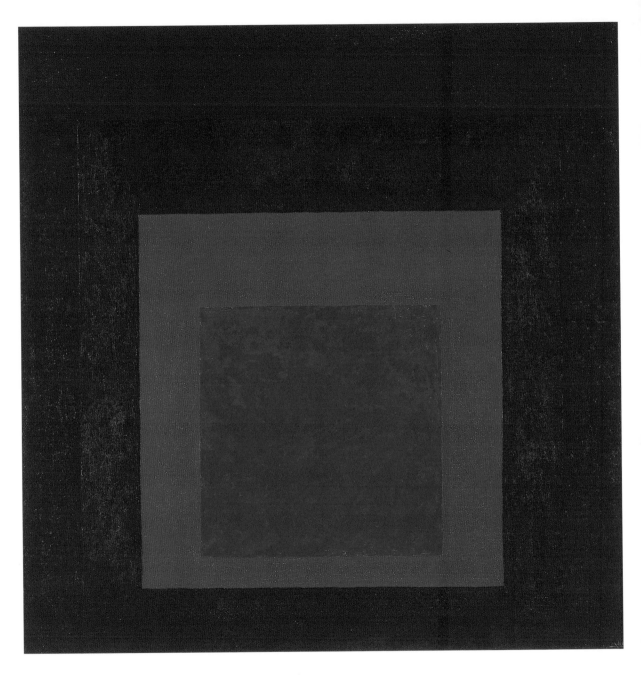

2 Josef Albers, *Study in Homage to the Square: 'Blue Deepness'*,
 1961, oil on hardboard, Gemeentemuseum, The Hague.

anyone and everyone would be able to understand what they were about.

When Hitler came to power in Germany, Albers escaped to the United States. Towards the close of the 1940s he began a fundamental research programme which gradually attained impressive proportions. He made a series of formal studies entitled *Homage to the square*, of which the painting in The Hague is one. With meticulous care the artist demonstrates the optical effect of the interaction of a number of differently coloured squares and rectangles of increasing size. Albers was only interested in a couple of very simple matters: size and colour, and the relationship between them.

Put like that, you might find it pretty dull and boring. But it is truly astonishing to detect the difference when you change the order of just one of the colours. The same square constellation then sends out a completely different message. And if you turn the painting in The Hague upside-down, for example, the impression it makes changes totally. Now the area at the centre, framed by the scarlet and crimson sections, looks like a receding blue depth. But give it a green outer frame and you have an entirely new picture (fig. 3). By looking at his preliminary studies we can observe the meticulous care with which Albers determined the exact dimensions of his pictures, and the relationships within them.

The systematic approach of Albers when painting these squares might appear unique. However, the twentieth century in particular saw an increasing number of artists beginning to work in this methodical manner, undertaking fundamental artistic experiments. The Swiss artist Richard Lohse has created an oeuvre that possibly supersedes Albers in its coherent design. All his paintings are compositions of precisely calculated mathematical areas using colours that are created according to strict systems. The Hague's Gemeentemuseum has a work by him dating from 1968 (fig. 4).

At the centre the artist has placed a nucleus of four small blocks. The upper two each have a primary colour, red and blue. Diagonally below these are blocks bearing complementary primary colours, orange opposite the blue, green opposite the red. A band of blocks of the same size surrounds this, the only point being that the colours have been shifted by one hundred and eighty degrees. In the left and right lower corners are, respectively, blue and red, while green and orange are now transposed to the upper corners. The other squares forming this frame are coloured in with intervening tones of the four main pigments used.

Around the centre the play of changing colours repeats itself. In a way it appears as if Lohse is making the motif of his painting more complicated – the blocks now become four times larger. However, it also means that he can continue with the same palette and doesn't have to mix

3 Because of their different colour combinations, the pictures
Albers painted titled *Homage to the Square* each have a
surprisingly different ambience.

4 Richard Lohse, *Four Systematic Groups of Paint
 with a Reduced Centre*, 1968, oil on canvas,
 Gemeentemuseum, The Hague.

5 Peter Struycken, *Computer Structure 6a*, 1969,
 varnish on latex, Gemeentemuseum, The Hague.

further colours. Seen in this way, the artist is simply continuing his system and making efficient use of the materials available. A row further out from the centre he once more increases the size of his squares, and then again, and then once more. The end result of Lohse's consistent pictorial investigation is a cheerfully flickering scene in which we detect a subtly spiralling movement.

The Netherlands boasts another engineer-artist who decided to go one step further than Albers and Lohse. Peter Struycken felt it was time not only to rationalize art, but also to digitalize it. He expanded his artistic horizon to include computer-generated art. He let the computer generate all possible variations on a square divided into four quadrants, each quadrant being allowed to vary in intensity from white to black. Then he wrote a program to produce all possible variations on these squares. Rejecting some of the squares, he instructed the computer to produce various patterns from the rest. Finally, Struycken combined some of these into a painting (fig. 5).

It's not uncommon to hear people saying scornfully of a piece of modern art, 'My two-year-old could do better!' A similar sneer is sometimes levelled at Struycken and his ilk. This isn't art, runs the argument, it's all generated by a computer, and there's not a grain of human creativity to be seen. This is patently not so. All the computer does is provide artists with options; it is their decision what to reject and what to accept. In the choice and presentation of a particular motif or pattern lies the human creative aspect. There seems to be an instinctive notion that art and science don't combine, indeed, that they conflict with each other. Nevertheless, there are artists following the footsteps of Leonardo who put paid to this idea. They demonstrate that the two may be happily married, and their systematic exploration of reality often produces pictures that are exciting and stimulating. Not least because they need no verbal explanation – just looking at them is enough.

Hope of Liberation

There is a picture in The Hague's Mauritshuis painted by Hendrick ter Brugghen in 1624 that never fails to arrest my attention (fig. 1). It makes a huge emotional impact. I pause to look at it, and long after I've turned away, it stays imprinted on my memory. From above left a bright light falls upon the bare back of a young angelic figure. Bending forward and gently laying a hand upon the shoulder of an old man who sits hunched and handcuffed, the angel gestures with the other hand towards the sky. The white-bearded man appears bemused – evidently he hadn't anticipated angelic help. The two figures are sharply contrasted: the dishevelled world-weary old man beside the energetic elegant young messenger – even without knowing who they are, here is excitement, here is drama.

Although initially it's not obvious what this painting represents, in fact it's quite easy to trace the story. For in the German city of Schwerin there is a canvas on which Ter Brugghen has painted exactly the same event (fig. 2). In this case he has allowed his two people more room and now we realize that the white-haired old man must be St Peter. For at his feet lie a pair of large keys, the symbol of the apostle who guards the gate to the Kingdom of Heaven and upon whom the Church of

Christ was built. The biblical book of the Acts of the Apostles describes how Peter was imprisoned by King Herod and lay awaiting execution. Then an angel awakened him and led him out of prison.

Not only the lack of symbolic clues but above all the powerful drama in the Mauritshuis painting prevented me from identifying the scene straight away. I am only familiar with gentle representations of this scene from early Italian works. The Brancacci chapel of the church of Santa Maria del Carmine in Florence is primarily famous for its murals painted by the Renaissance pioneer Masaccio. About fifteen years after he was busy there, another artist, Filippino Lippi, painted frescoes on the remaining walls that were as yet uncovered. One of these shows the liberation of St Peter (fig. 3). The apostle is shown sauntering calmly through the prison doorway, while a relaxed-looking angel sees him off.

It is hard to imagine how this very laid-back scene – in Filippino's picture everything seems quietly matter of course – gradually developed into so passionate a rendering. And in fact that's not what happened. During the seventeenth century the liberation of Peter became a very popular theme among the Dutch Roman Catholics. It's not difficult to understand this,

1 Hendrik ter Brugghen, *The Liberation of Peter*, 1624,
 oil on canvas, Maurtishuis, The Hague.

2 Hendrik ter Brugghen, *The Liberation of Peter*, 1629,
oil on canvas, Staatliches Museum, Schwerin.

in view of the historical situation at the time. After the sixteenth-century Reformation in the Christian church, the major Dutch church in the Northern Netherlands became Protestant, and the Catholics had to worship in secret. Cherishing the hope that the Mother Church of Rome would one day be restored as the official religion, they clung onto straws of comfort. What could be more encouraging than the miraculous liberation from chains of the first bishop of Rome?

This still doesn't explain how Ter Brugghen came to create such a gripping scene. What inspired his vivid pictorial language? That too came from Rome. There, early in the seventeenth century, the famous artist Caravaggio introduced a new manner of depiction. He strove to discover the essence of a picture and felt that the viewer should be able to appreciate the scene represented upon a canvas and feel its power from close by. The Roman church of Santa Maria del Popolo houses one of Caravaggio's finest works, which Ter Brugghen would undoubtedly have seen during his stay in Italy. It shows the Martyrdom of St Peter (fig. 4). After the apostle had been set free from Herod's prison, he nevertheless met a violent end. When Nero was emperor in Rome, Peter was crucified, upside-down at his special request, because he deemed himself unworthy to die the same way as his Lord and Master. Characteristic of Caravaggio's approach is the way he shows the physical details of the crucifixion itself, deliberately eschewing a less gruesome scene.

Indeed, the master has employed a number of artistic devices by which to involve the viewer's feelings. He increases the tension and concentration by showing only a few figures emerging from the dark background. To create a sense of nearness he places his figures in the foreground, almost on the edge of the painting or has them bleeding off beyond the picture frame. Unlike many other artists, Caravaggio used models he picked up in the street, often strikingly unlovely people. No super heroic beauties for him. His saints and his hangmen are ordinary folk with dirty feet and fat paunches. Not surprisingly, his contemporaries were highly shocked by Caravaggio's portrayals. At the same time he compelled people to look at religious stories as real events.

A story in itself, Caravaggio's turbulent lifestyle soon led to his disfavour with the mighty, and an early, violent death. But his way of painting attracted large numbers of followers and inspired artists from many countries. In the Netherlands it was chiefly a group of painters from Utrecht, the city where Ter Brugghen came from. In Utrecht's Centraal Museum there is an impressive collection of the artists known as the Utrecht Caravaggists, including work by such seventeenth-century masters as Gerrit van Honthorst and Dirck van Baburen.

3 Filippino Lippi, *The Liberation of Peter*, c. 1482, fresco,
Santa Maria del Carmine, Florence.

After this little digression the question still remains: what is it in this painting by Ter Brugghen that I find so appealing? Why is this picture so engrained in my memory, and why does it move me time and again whenever I see it? I think it must be the contrast between the young figure bursting with life and the crum-pled old man, and the way Youth, gently touching Age, restores life and wakefulness to the dishevelled sleeping body. The chains represent far more than Peter's imprisoned state. This is a picture for all prisoners of any kind, for all those shackled by doubt and misery. It promises hope of liberation – freedom and a better life.

4. Michelangelo Merisi da Caravaggio, *Martydom of St Peter*, c.
1600, oil on canvas, Santa Maria del Popolo, Rome.

Feelings we'd Rather Avoid

The Boijmans Van Beuningen Museum in Rotterdam has a terrifying canvas by the British painter Francis Bacon (1909 – 1992). It makes you think of the boardroom of a multinational, with a solitary figure dressed in a smart suit seated on a chair (fig. 1). But you can't see who it is – rough smears of paint obscure and almost distort his face. The gesture of his arm is aggressive, as if repelling an attack. The background, too, makes us feel uncomfortable. It is dark and only minimally suggested, but the space appears far too large for the lone figure. Briefly, you are imprisoned in the icy emptiness of polished furniture. You suddenly feel small and insignificant, stripped of all value. Many of Bacon's pictures project a feeling that he is confined, suffering endlessly, with no hope of reprieve.

Another work hanging in the Rotterdam museum demonstrates this fearful tension even more strongly (fig. 2). No longer can we speak of a human figure. All we see is a couple of bloody hunks of flesh whose exact nature is difficult to describe. In the lower part of the canvas we make out a wide-open mouth, apparently screaming aloud in agonized oppression. The two lumps of meat appear to have been flung against a T-shaped cross. The canvas is titled *Fragment of a Crucifixion*.

Here again the artist has introduced depth in a remarkably effective manner. The horizontal beam of the cross is directed backwards at a slight angle. Then Bacon has drawn a puzzling perspectival grid of white lines over which the lower lump of meat seems to hang. This causes the picture to break open, although without bringing any more space into it. The suggestion, momentarily offered, of room to move in, is immediately refuted for there are no lines leading into the background to suggest depth. Stick figures and cars move against the glittering blue skyline, but no one pays any attention to what's happening in the foreground. This adds to the tension in the scene.

Bacon was apparently fascinated by certain themes and painted them repeatedly. He took one of them from the seventeenth-century Spanish artist Diego Velázquez. The latter painted a portrait of Pope Innocent x in around 1650. The Spanish master was famous for never idealizing the sitters in his portraits. So today we are familiar with the malignant gaze of this particular papal scowl. Probably that's what fascinated Bacon. He gave his imagination full rein and constructed a picture with a monster's

1 Francis Bacon, *Man in Blue I*, 1954, oil on canvas, Boijmans Van Beuningen Museum, Rotterdam.

2 Francis Bacon, *Fragment of a Crucifixion*, 1950, oil on canvas,
 Boijmans van Beuningen Museum, Rotterdam (on loan from
 the Municipal Van Abbemuseum, Eindhoven).

head that if you look at it too long is enough to produce a nervous breakdown (fig. 3). Another painting by Bacon, this time in The Hague's Gemeentemuseum, illustrates how he gained inspiration not only from the traditional art of old masters but from other sources, too (fig. 4). Again, the scene is set in an unfathomable space, with the green ground colour merging into a yawning black nothingness. A light-painted window frame in the foreground provides a powerful sense of distance. The artist has organized the composition in the manner of a stage director. In the theatre a producer will often place an actor alone on the stage in a totally empty set in order to project a feeling of existential loneliness. In making this piece Bacon has studied both the theatre and photography. Because of its nakedness, we feel moved by this crawling creature. At the same time we are repelled, for it has no recognizable features. It is based on a series of pictures taken by the British-born Eadweard Muybridge (1830 – 1904). Working in California in the 1880s, Muybridge developed a method of recording the movement of people and animals on film, capturing each successive stage in, for example, a dog's running. He asked people to perform a wide range of activities in front of the camera. One of them was a polio patient, who demonstrated a method of moving on all fours (fig. 5). The painting in The Hague shows how Bacon isolated one image from Muybridge's series in which the child's legs appear almost stuck together. The same child appears in a painting presently in Amsterdam's Stedelijk Museum, in a slightly different pose (fig. 6). On the other side of a rack-like construction, a female figure balances who can be traced to another photographic series by Muybridge. The photographer captured her in the act of emptying a bucket of water. In Bacon's contorted vision, all that remains to be seen is the splashing jet of water. The colours of the Amsterdam canvas are vivid, almost cheerful, when compared with other paintings by Bacon. Nevertheless, the chief sensations are of gloom and oppression. The misshapen bodies are doomed to hobble around forever in an emptiness from which there is no escape. The violent colours are intentionally out of place, creating a powerfully intense illusion of cheerfulness. Bacon paints an astonishing world, in which our most terrifying nightmares pale to insignificance. The images arose, he once recalled, out of the deepest places of his imagination where he encountered the monster that is called a human being. Convinced that the evil within people was inextricably part of the human condition, Bacon could never bring himself to paint a smile. So his themes are aggression, vulnerability, exhibitionism and loneliness. He presents these with incomparable power and poignancy. He shows the feelings that most of us would rather avoid.

3 Based on a portrait by Velázquez, Francis Bacon transformed
 the face of Pope Innocent x into that of a frightening monster.

4 Francis Bacon, *Child with Poliomyelitis Walking on Hands and Feet*, 1961, oil on canvas, Gemeentemuseum, The Hague.

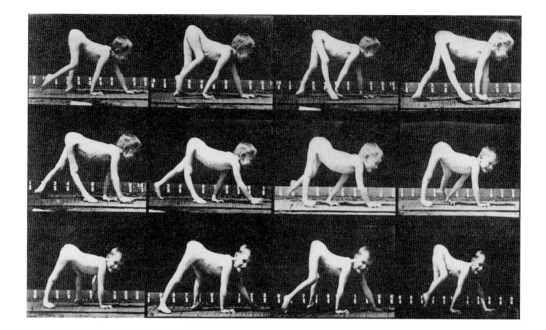

5 At the end of the eighteenth century, the photographer
Muybridge developed a method for recording the
stages of people and animals in motion.

5 Francis Bacon, *After Muybridge, Studies of the Human Body,*
 Woman Emptying a Pail of Water and Child Crawling, 1965,
 oil on canvas, Stedelijk Museum, Amsterdam.

Artists, Candlelight and the Sublime

Candles, it could justifiably be said, are an important feature in many a painting. Their delicate, dim light allows the painter to create a scene that looms dramatically out of the dark background. In the museum of Den Bosch in North Brabant hangs a picture by the nineteenth century artist Petrus van Schendel which is an excellent illustration of this principle (fig. 1). The artist has chosen a traditional theme: the temptation of St Anthony. This unfortunate man was beset by wily women who tried to seduce him away from his ascetic life. But the saint resisted all their attempts by steadfastly praying. Van Schendel has rendered the scene with utmost seemliness, unlike some of his colleagues from earlier periods. Here we see no lascivious females, but an alluring candle, dispelling the darkness and gradually revealing the temptation scene.

Evidently, painting candlelit scenes was all the fashion in this part of the Netherlands in the nineteenth century. We may deduce this from the pictures in the Noordbrabants Museum where close to the canvas just mentioned hangs a panel by Van Schendel's colleague, Jan Hendrik van Grootvelt, that reveals its details in a comparable twilight glow (fig. 2). So you begin to wonder when this special effect was first used in painting –

who introduced this literally luminous idea? The earliest known night scenes with one bright source of light were made in Italy. The idea travelled to Holland and reached Rembrandt via the Utrecht artist Gerard van Honthorst. Early in his career and still working in his native city of Leiden, Rembrandt produced small paintings which he executed in meticulous detail. The scenes are frequently

1 Petrus van Schendel, *The Temptation of St Anthony*, 1838, oil on canvas, Noordbrabants Museum, Den Bosch.

2 Jan Hendrik van Grootvelt, *Candlelight Interior
with a Peddler*, 1837, oil on panel, Noordbrabants
Museum, Den Bosch.

given a shadowy setting which stimulates the imagination. The only bright elements in the composition are the important motifs, usually illuminated by the flame of a single candle. These concentrated small pictures by Rembrandt were very popular, and he soon had imitators, first in Leiden and shortly after that, elsewhere. The name given to this pre-eminently Dutch genre of painting was *fijnschilderen*. *Fijnschilder* paintings are characterized by their small size, their meticulous attention to detail, and their satin-smooth, 'fine' finish. One of the outstanding masters of this genre was a pupil of Rembrandt's, Gerard Dou. In Leiden's Municipal Museum De Lakenhal, there is a superb example of his work. The panel shows an astronomer studying a celestial globe by the light of a candle. Obviously, Dou would picture the man in a dark setting – after all, astronomy is pre-eminently a night-time occupation.

In the course of the seventeenth century, many *fijnschilders* specialized further, according to their preferences and their possibilities. One of these artists, Godfried Schalcken (1643 – 1706), may deservedly be hailed as the Candle King. In almost everything he painted a candle flame can be seen. Indeed, Schalcken's virtuosity resulted in the candlelight becoming the core of his work, while the initial subject dwindled into second place. This is even so of his portrait of the stadholder-king, William III, presently in Amsterdam's Rijksmuseum (fig. 3). Schalcken

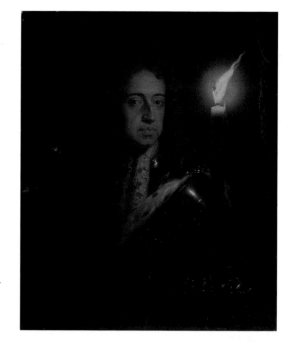

3 Godfried Schalcken, *William III by Candlelight*, c. 1689, oil on canvas, Rijksmuseum, Amsterdam.

developed the motif of the candle into an artistic device, but his undeniable painterly skills ensured that it never turned into a tasteless gimmick.

Another seventeenth century master, the French Georges de la Tour (1593 – 1652), aimed to achieve the effect of supreme stillness. One of the loveliest works to issue from his atelier can now be seen in Berlin (fig. 4). It shows St Sebastian, a Roman soldier, who practised his Christian faith in secret. But when it was discovered, the non-Christian archers shot him full of arrows. There are some pictures of him where he looks rather like a hedgehog as a

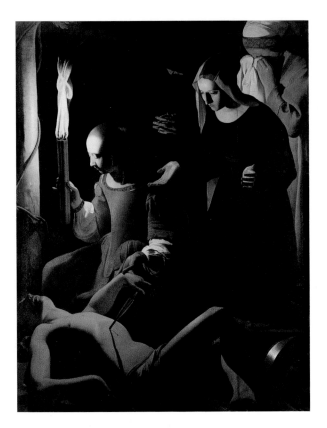

4 Georges de la Tour, *St Irene Discovering St Sebastian*, c. 1640,
oil on canvas, Gemäldegalerie Staatliche Museen, Berlin.

result. But in this painting he lies with only one arrow to tell of his martyrdom. His broken body was found by Irene, the widow of one of his fellow believers, who prepared him for burial. Here she is seen with some sorrowing friends. The candlelight brings a suitably soft, muted quality to the melancholy scene.

But there is something else we notice here.

In the candlelit paintings so far discussed, the figures were fairly clearly shown, and the other pic-torial elements could be distinguished in detail. Here on the De la Tour canvas in Berlin, we are only shown global forms – as indeed you would actually see shapes by candlelight. All the shapes are simplified, back to basics. This explains why when De la Tour was rediscovered at the beginning of the twentieth century, he was greatly admired by the Cubists and other modernists. We've been looking at how artists from previous centuries conjured scenes out of the shadowy background. However, this isn't something totally foreign to contemporary art. The De Pont Museum in the southern Dutch city of Tilburg asked the American James Turrell to make an installation (fig. 5). You reach this work by first walking down a pitch-black corridor. Turning the corner you begin to detect a purple glow. Soon you are aware of a space around you, though it's difficult to estimate its size. Concealed lamps (not candles this time) create a soft dusky glow, the illusion of an endless luminous space. Serenity prevails. You feel almost as if you're floating. In fact, Turrell has realized in a concrete and extreme form what many of his predecessors were aiming at through their paintings: he leads you from the shadowy darkness into the sublime light.

5 James Turrell, *Wedgwork III*, 1969, fluorescent light,
Stichting voor Hedendaagse Kunst (Foundation for
Contemporary Art) De Pont, Tilburg.

Handbook of a Medieval Painter

Sometime in the fifteenth century the eminent Flemish artist Rogier van der Weyden received a prestigious commission. No-one less than the bishop of the bustling town of Tournai approached him and said, 'I'd like you to make a painting illustrating the seven sacraments.' Ask anyone today to tell you what a sacrament is – or, still worse, how many of them there are – and as likely as not you'd be met with a blank stare. You'd need to find someone well trained in their catechism to explain that the sacraments of the church are 'the outward and visible forms' reflecting 'an inward and spiritual grace'. In the Roman Catholic church there are seven of them, namely, baptism, confirmation, confession, Eucharist, priestly ordination, marriage, and extreme unction. They illustrate all the significant events in people's lives where the church plays a major role. But how do you picture such moments of grace? In Antwerp's Museum of Fine Arts you can see how Rogier went about solving the problem (fig. 1).

His *Seven Sacraments Altarpiece* is simply fabulous. It speaks down the centuries to today's viewer, who doesn't need to know anything about the institutions of the church to appreciate the extraordinary quality of this painting. The bishop's request challenged Rogier to produce some inspired solutions. In the first place,

he thought of introducing some kind of coherence into the whole – not seven disconnected sub-sections, but a unifying concept. He took the notion of an altarpiece as it was in his day, a triptych, or three hinged panels, and he envisioned it as a vast continuous space. The triptych opens up before us, becoming the cross-section of a church interior. This is a brilliant idea, not only from an artistic point of view, but also with respect to content. There is no shape that could be more appropriate to consider the churchly aspect of this theme.

The central panel of Rogier's painting represents the Eucharist, the sacrament that binds believers each day once again with their Saviour. We see a priest in the background beside the altar, consecrating the Host, or 'bread' that will miraculously become the body of Christ. This central Christian sacrament makes Christ tangible and visible, and recalls his sacrificial death on the Cross. Above the altar floats an angel with a banderole bearing the words, 'This bread, by the action of the Holy Spirit, is transformed into the body of a Virgin, and through the fire of the Passion made perfect upon the Cross.' Many people today will find this a somewhat cryptic message, telling the viewers that they are witnessing a type of reincarnation, which is ritually repeated, again

1 Rogier van der Weyden, *The Seven Sacraments Altarpiece*,

 c. 1441, oil on panel, Musée Royal des Beaux-Arts, Antwerp.

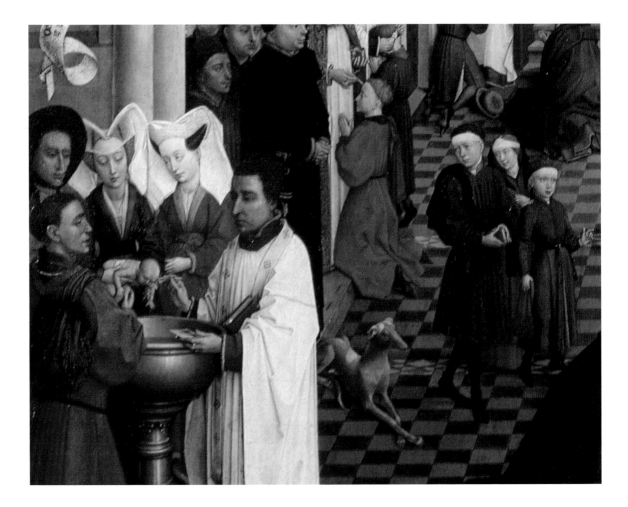

2 Baptism.

3 Confession.

and again, for the salvation of the believing community.

In the foreground we see an illustration of the phrase 'the fire of the Passion'. High in the main nave of the church, the figure of Christ hangs in death. Round the foot of the Cross, as in many a medieval painting, are grouped the figures of Mary the mother of Jesus, John the Beloved Disciple, and the other Marys. Entering the church where this triptych was to be placed, you would thus be confronted with the heart of the Christian gospel, the crux of Christian belief. This representation in itself amply shows what a remarkable conceptualist Rogier was. With an impressive picture he presents the intricate theological concept of sacrifice and salvation.

The side panels of the triptych illustrate the other sacraments. On the left we start with baptism, observed from on high by an angel clothed in white (fig. 2). This is the colour of innocence – the newly born child is cleansed from the original sin that stains all humankind. The angels are all robed in gowns of differing colours, signifying the liturgical event with which they are being associated. The yellow garments of the angel who introduces confirmation refer to the fire of purification while the red of the angel linked to confession, signifies repentance (fig. 3). On the right-hand wing of the triptych the scene in the background shows the ordination of a priest with an angel resplend-

4 Marriage.

5 The sacrament of the dying, extreme unction, also known as
 the last rites.

ent in royal purple. In the centre a marriage ceremony is being performed; the small dog seen here stands for fidelity, as does the colour blue of the angel (fig. 4).

Appropriately, for the sacrament of extreme unction, or last rites, shown in the foreground right, the angel wears black (fig. 5). Just by looking at this remarkable painting, you can certainly learn a great deal. Indeed, the work in Antwerp is often used as a kind of Book of Instruction. Schoolchildren learning their catechism come and take a look at it – for here you have all seven sacraments perfectly illustrated. Undoubtedly, that was one of the intentions of the good bishop who commissioned the work. But another of its original components has been lost. For when it was first completed, the painting stood upon a church altar. It had a religious context out of which many associations arose naturally – now we have to think hard in order to reconstruct them.

Something else – Rogier's contemporary viewers saw in the picture the interior of a church which would have been immediately familiar. The people in the pictures are wearing the clothes of their time, which would have been the same as the viewer's. The people of Tournai might even recognize some of their fellow citizens – for the bishop is immortalized as the priest who performs the sacrament of confirmation. Clearly, when it was fresh in the world, this painting would have been like a newspaper hot from the press – with an immediacy we can no longer appreciate.

Cherishing Inanimate Objects

People can get remarkably emotional about teddy bears (fig. 1). That's rather curious if you think about it, because a teddy is nothing more than a piece of textile encasing a few handfuls of sawdust or foam rubber. At best it has two beads for eyes, but you can't avoid the truth of the matter – it's not alive. Yet without the slightest difficulty we can bestow upon these objects the kinds of feelings that are usually reserved for interpersonal relationships. Indeed, many people will probably feel deeply insulted that I call a teddy bear a 'thing'. Nevertheless, that's what it is. The ability to project human

1 People lavish enormous affection on their teddy bears, even though they are inanimate objects.

emotions onto inanimate objects isn't anything new. Already in the late Middle Ages we have instances of just this – objects treated as if they were alive. In Antwerp's Mayer van den Bergh Museum there is a charming example of this (fig. 2).

It is an exquisitely crafted, doll-sized infant's cradle, that can really rock to and fro. It comes from a nuns' cloister. Women would join a cloister and dedicate themselves to a life of faith. When you joined a religious order, you renounced your family and friends. Henceforth, however, you would have something in their place. The emotions that were usually shared with dear friends and relations could be transferred within the convent walls in a spiritual manner to the adoration of Christ. The person of Christ became so real that he was, as it were, reborn for the worshipping nun. And in the convent cradles he could be cherished like your own baby. Originally, this cradle in the Antwerp museum also contained a Baby Jesus doll. Unfortunately, this has probably been lost – at all events, the baby has become separated from its little cot.

In some places, however, there are still medieval dolls representing the Baby Jesus. Amsterdam's Rijksmuseum has one such that was formerly the pet of a nuns' convent. Just like a teddy bear today, such dolls were once enormously popular. In the Belgian town of Mechlin, a flourishing industry developed at

2 A cradle for Baby Jesus, Southern Netherlands, c. 1475,
 gilded oak, Mayer van den Bergh Museum, Antwerp.

3 The Christ Child giving a blessing, Mechlin,
 c. 1500, polychromed oak and textile,
 Staatliches Museum, Schwerin.

4 A cradle for Baby Jesus, Liège, c. 1400, silver gilt,
 Musée des Arts Anciens, Namur.

one time, since there was so much demand for the baby dolls. There was ample employment for woodcarvers and painters, as well as other skilled craftspeople. After all, the dolls couldn't remain with no clothes on, so all kinds of garments and accessories had to be produced. In the German town of Schwerin, the museum has a Jesus doll similar to the one in Amsterdam's Rijksmuseum, but this time fully clothed (fig. 3). Decked out in full glory, what was once a vulnerable and endearing bare baby becomes the King and Saviour of the World.

Wooden cradles like the one in the Antwerp museum were very common in the late Middle Ages. Young women from noble families who entered a convent would try to take something costly to compensate for all the sobriety, moderation and self-abnegation that would in future be demanded of them. So they would order a cradle to be made from precious metal. Only one such seems to have survived the centuries, an intricate silver creation now in the Museum of Ancient Arts in Namur (fig. 4). And here the baby doll that went with the crib has also survived. Small bells hang beneath the cradle to lull the child asleep with their gentle tinkling. As we have seen, many of these devotional dolls were produced en masse in the Southern Netherlands. Sometimes, however, a master artist would be commissioned to make such a figure. A superb woodcarver from southern Germany, Gregor Erhart, made a beautiful

cuddly baby Jesus, presently in Hamburg's Museum for Applied Arts (fig. 5). The baby is life-size, utterly delightful, and has a powerfully attractive sweetness of expression. With this toddler's chubby charm it's not hard to imagine people coming to talk to him, to confide their cares in him, or to worship him in all humility. A wooden image.

In the Mayer van den Bergh Museum, where we began, there is another object connected with the mystical world of the nuns. It is a statue of Christ with John the Beloved Disciple (fig. 6). Jesus is comforting the sorrowing John, who rests his head on his master's shoulder. This recalls a moment during the Last Supper frequently represented in paintings and sculptures, with the two figures shown close together and the other disciples seated around. There is an explicit description of the incident in the Gospels. In the late Middle Ages the two figures, with Christ comforting John, were isolated from the rest of the scene and became a separate motif. Thus, a deeply moving image was created, showing affectionate intimacy. Interestingly, John here has the face of a young woman, presumably intentionally. For this type of sculpture belonged in a nuns' convent, where the sisters would be able to identify with the

5 Gregor Erhart, The Infant Christ holding the world orb, c. 1500, polychromed limewood, Museum für Kunst und Gewerbe, Hamburg.

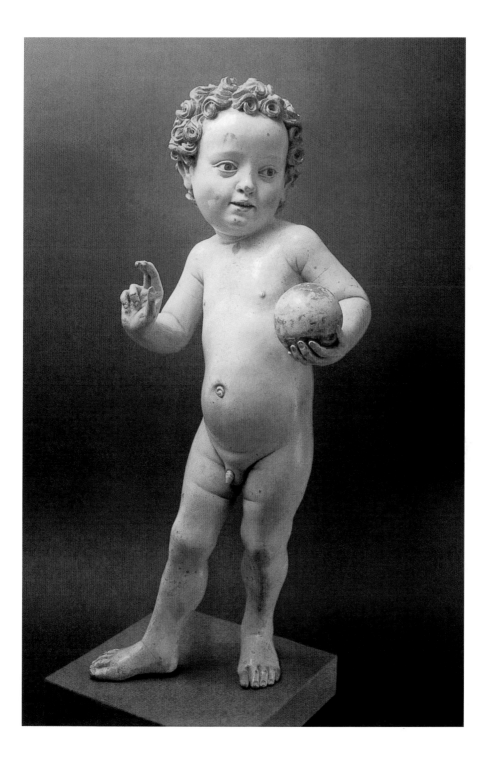

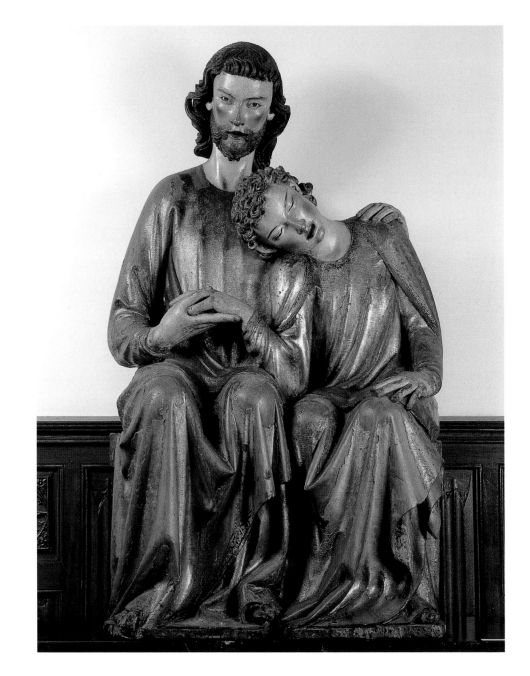

6 Master Heinrich of Constance, John the Beloved Disciple resting
his head upon the breast of Christ, early 14th century, polychromed
nutwood, Mayer van den Bergh Museum, Antwerp.

somewhat androgynous person of the young disciple. They could fantasize that they rested, blissfully embraced, comforted and secure upon their Master's breast.

The cradle and the carving in Antwerp illustrate the imagination of late medieval people and their ability to sublimate – as we would say today – their emotions. Although they had forsworn the world and all its attractions, the nuns could still experience feelings of caring and tenderness, and lavish their affections on these inanimate objects, albeit in a metaphorical manner. And happily, today we also have our toys to cuddle and care for. Sweet dreams, teddy dear.

Rubens as Artistic Director

1 Thanks to the time machine invented by Professor Barnabas, the comic figure Orville finds himself in the workshop of the seventeenth-century Flemish painter, Peter Paul Rubens.

One of my favourite comic strips is from the Belgian series about the amusing adventures of *Suske and Wiske*, or *Willy and Wanda* as they are known in the American edition. The story I'm thinking of is entitled (something like) *Rubens Reigns*. Using Professor Barnabas's time machine, the comic character Orville is sent

back into the seventeenth century. Since he fancies himself as a bit of an artist, Orville is allowed to visit the workshop of the greatest Flemish painter of the day, Peter Paul Rubens (1577 – 1640). This master didn't live in your run-down garret like some artists. Being so acclaimed a painter, he could afford a luxurious house. Here Orville meets not only Rubens himself but also his two most prominent pupils, Jacob Jordaens and Anthony van Dyck. The cartoon hero proffers his services and, like the two more renowned painters, is taken on as an apprentice in Rubens's workshop. And naturally everything goes wrong for Orville. It soon becomes clear that his artistic talent is decidedly limited, and then he fails to come up with the goods as artist's model. Posing as Cupid, he starts shooting arrows all over the place. And of course, he encounters the type of woman for whom the adjective 'Rubenesque' was coined, of exceedingly generous proportions and fond of revealing the naked flesh. Finally, Orville forms part of a scene filled with people and animals, representing the *Adoration of the Magi*, one of the Flemish master's most well-known pictures (fig. 1).

2 Peter Paul Rubens, *The Adoration of the Magi*, 1625, oil on panel, Musée Royal des Beaux-Arts, Antwerp.

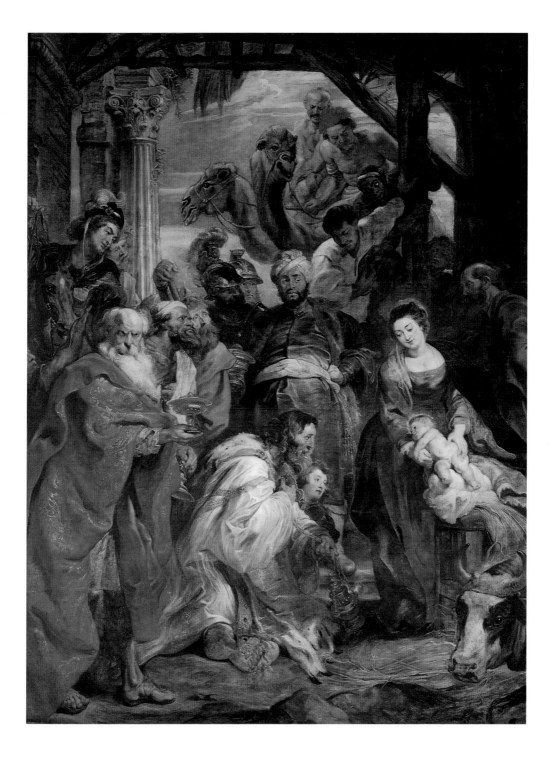

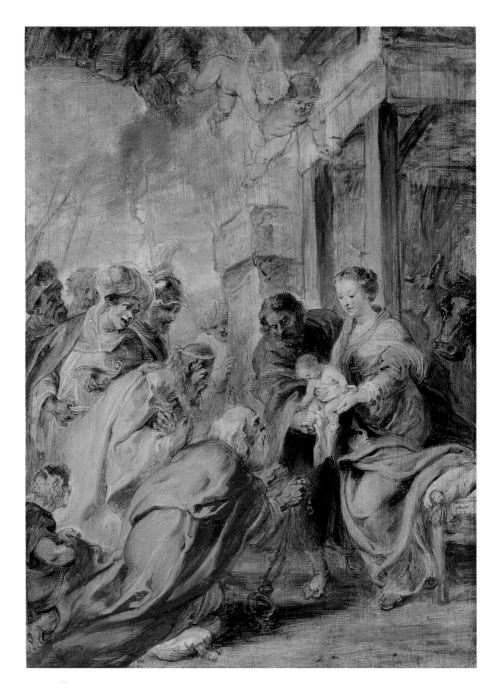

3 Peter Paul Rubens, *The Adoration of the Magi*, 1624,
 oil on panel, Wallace Collection, London.

4 Not only did Rubens make oil sketches, he also drew quantities of prelimi-
 nary and detail studies before he launched into the definitive painting.

5 Peter Paul Rubens, *The Crucifixion*, 1620, oil on panel,
 Musée Royal des Beaux-Arts, Antwerp.

The truly monumental painting that plays a key part in this cartoon story now hangs in Antwerp's Museum of Fine Arts (fig. 2). Looking at the picture, you imagine it was painted in one fell sweep of the brush, it has such dynamism and close-packed composition. Of course, that's impossible – the work is far too large, for one thing. But this brings us very close to understanding the enormous power of Rubens's paintings. His was the genius that could project the most complicated scenes and make them appear simple and self-evident. How did he do it – achieving a sense of immediacy combined with meticulously calculated effects? How, in fact, did he construct his pictures?

What we find is two architectural elements buttressing this composition, to wit, the pillar in the left background and the wooden beams in the stable at the right. They function as artistic devices to direct the viewer's eye into the picture. In Rubens's scene they serve as visual supports for the rest of the composition, and each figure is related to them in some way. The three kings, the wise men from the East, travelled on camels, and we see these splendid beasts in the background. Rubens has incorporated them into the scene, and their heads provide a spectacular decor. The kings themselves emanate power and vitality. The old king in the left foreground seems almost to grow out of the ground. He has been copied by countless artists after Rubens, who adapted the figure to suit their own stories. Indeed, in the comic strip we are discussing, he also plays the mysterious lead role.

Yet despite the apparent spontaneity, Rubens went over his work many times, planning and revising his compositions. This can be clearly seen if we look at an oil sketch in London's Wallace Collection (fig. 3). This type of sketch done in oils was a kind of 'try-out' to see what the picture would look like. Oil sketches would also be shown to clients, hopefully to meet their approval, and could be used to instruct the apprentice artists.

The figure that I'm particularly interested in is that of Mary. In the London sketch her stance is quite different to that in the final version hanging in Antwerp. She bends forward in the London picture, as if moving to meet the kings. This pose makes her appear somewhat ingratiating and also disturbs the tension in the picture's composition. In the final version Mary appears more relaxed. The delicate curve of her body underscores in a satisfying manner the architectural shapes behind her. Surrounded by these shapes and lines, the Infant Christ is also given a more vibrant role and becomes, as it were, the bridge between his mother and the three kings.

Not only did Rubens make oil sketches, he also drew quantities of preliminary studies before he launched into a large painting (fig. 4). Making individual, separate studies of heads, hands and

figures, he would work out precisely how to position the characters on his canvas. Only at the last moment did the master bring everything together. This was also when he divided up the tasks among his pupils and assistants. This way he showed that he was, in many respects, a gifted and dynamic artistic director. Antwerp's Museum of Fine Arts has yet another splendid painting by the master. It is a monumental Crucifixion scene (fig. 5). Looking at this huge altarpiece, you realize why Rubens made such an enormous impact on so many artists who came after him. For centuries there had been an accepted scheme for a Crucifixion picture (fig. 6). In the centre, the figure of Christ hung on the Cross, facing the spectator. Placed symmetrically on either side were the crosses of the two thieves. The number of figures on the ground could vary, but they were commonly grouped in an accepted pattern.

It would seem that Rubens was tired of these conventions. He devised his own picture of the scene at Golgotha. The main players were given a kind of narrow apron stage and the three crosses form a wavy diagonal in the space behind. As it says in the Gospels, the sky grew dark and the earth rumbled, and in Rubens's painting this doom-laden setting is clearly shown. Against an ink-black sky the body of Christ gleams vividly in the centre of the picture. It is a warm, powerful body, and our eyes are drawn towards it. We see the bleeding feet,

in emphatic contrast to the grief-stricken Mary Magdalene who is shown immediately beneath them.

Rubens takes the well-known formula and twists it round a little – now we see the scene from a new angle, and all sorts of possibilities arise. The first figure upon whom the eye falls is the bad robber, squirming in agony on his cross. His just deserts, some might say. And in contrast the good thief almost seems to step off his cross, and move towards Christ. With his body he speaks the words, 'Truly, this is the Son of God.' The Roman centurion whose task was to supervise the crucifixion is shown driving his spear into Christ's body, to ascertain that he was really dead.

Imagine the impact of a work like this on the wealthy Flemish citizens. Not only because of the dynamic power of the piece, but also because there would undoubtedly be some people you recognized in the painted scene. Wouldn't it be fantastic if Rubens were to paint my portrait, they must have reflected. And that's what Orville dreams of at the end of the cartoon in the *Wanda and Willy* adventure story. He imagines that the Flemish master has painted his noble figure and so immortalized him.

6 For centuries the Crucifixion scene had been shown according to a fixed formula. In the centre the cross of Christ, seen frontally, flanked by the crosses of the two thieves.

A Dazzling Madonna

When Barbie turned fifty, her makers decided it was time to update her image. What ideal should she project – luscious curves or the

1 Barbie has been updated to look more hip and cool.

Twiggy look? (fig. 1). Her 1950s image is well-known, comprising a wasp-waist, a substantial bosom and a 'Don't-touch-me' expression on her face. The vibes weren't too appealing. Fifty years on, it was thought time to re-style this icon and adapt her appearance to the trends of the day. She should look like the ideal attractive modern woman. So she was given a hip expan-

sion, a somewhat less voluptuous frontage and a friendly welcoming smile. Enter the charming young lady we all love. In Antwerp's Musée

Royal des Beaux-Arts there is a real knock-out Madonna and Child, painted by Jean Fouquet (1420 – 1481) (fig. 2). She always makes me think of Barbie – that is, the former, bosomy version, of course. This Madonna is so strongly

2 Jean Fouquet, *Madonna and Child*, c. 1451, oil on canvas, Musée Royal des Beaux-Arts, Antwerp.

3 Jean Fouquet, *Etienne Chevalier with St Stephen*, c. 1451, oil on
 panel, Gemäldegalerie Staatliche Museen, Berlin.

present that it was always something of a shock to encounter her in a room full of otherwise chaste versions of the Virgin and saints. There she is, with dazzling white skin, one bloated boob fully exposed, an arousing, challenging and slightly shocking manifestation.

Fouquet painted her in the mid-fifteenth century. Prior to this work there are only a few Italian artists who brought such potent realism to their figures. Evidently, the French master was inspired by their work and became possessed by the possibility of presenting three-dimensionality on a flat surface. The most blatant example of this is the one absurdly spherical, exposed breast of Mary. It is tantalisingly inviting, you almost want to stroke its rounded smoothness. The quality of the skin is as stunning in its painted perfection as is the marble of the throne upon which the Queen of Heaven is seated. Equally stunning in their plastic grace are the angels that surround the throne. The red, many-winged angles are seraphim and belong to the highest order of angels in the celestial hierarchy (cherubim are in the second order). They are generally depicted simply as winged faces, to emphasize their spiritual nature. They are red because they are aflame with love for God. Here, like the blue cherubim, the angels are all portrayed with bodies – presumably Fouquet could not resist physicality. His picture is completed by the crown on the Madonna's head, set with arresting precious stones. Painted with loving

realism, this picture has a lip-licking lusciousness to it, far from the realms of holy asceticism. Not surprisingly, Baby Jesus looks just a trifle embarrassed.

The painting in Antwerp was recently restored. It was then seen to possess an overwhelming strength and power. Of course, the exuberant shape of Mary had always been remarked upon. But the old yellowing layer of varnish had blunted the brightness and protected both the paint and the spectators' eyes. Once it was removed, the lady shone forth in all her dazzling brilliance. It looks like a merciless exposure of white flesh. The luminous reds and blues behind Mary combine to singe the eyes with brightness. And apparently the colour contrasts could have been even stronger, but the museum staff doing the restoration took pity on the public. The painting in Antwerp once had a pendant, which is happily preserved in a Berlin museum (fig. 3). The panel shows Etienne Chevalier, an important dignitary at the court of the French king Charles VII. The statesman is seen praying before the figure of Mary, to whom he is presented by St Stephen. Originally, both paintings were intended to decorate Chevalier's tomb and are known as the Melun Diptych.

Thus, we know the historical purpose of this Antwerp painting: it was in fact a grave piece. But various legends have grown up around this unusual Madonna. In the seventeenth century it was suggested that she resembled Agnes Sorel,

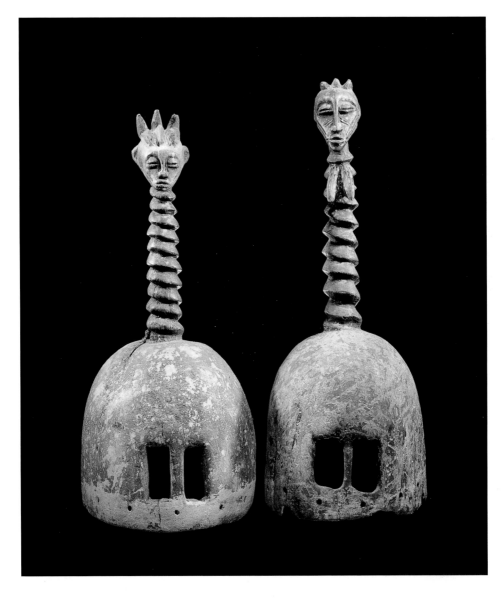

2 Masks with references to ancestors carved
 at the top, Senufo people, Côte d'Ivoire, wood,
 Afrika Museum, Berg en Dal.

3 A plank-mask used in male initiation rites,
 Tusyan people, Burkina Faso, wood, textile, seeds,
 Afrika Museum, Berg en Dal.

bell-jar or cloche hat (fig. 2). They have carved decorations on them, referring to venerated ancestors. These heads are set upon ridged sticks which represent the winding sheets wound around the corpse. In the culture where they originate, these masks would have been used in ceremonial events commemorating members of the family and community who had died. If someone placed one of these cloches over their head, the dead person would return for a short time.

In Africa, then, a mask isn't for disguise. You don't put on the outward appearance of another person, you actually receive another shape. Your own identity fades away until the moment when you take the mask off again. To emphasize this effect, many masks initially had raffia fringes while costumes with long pieces of fabric or strings attached at their edges were also worn. The wearers were able to hide completely and literally ceased to be themselves. A spirit was summoned up, in this case the spirit of an ancestor, who temporarily took possession of and inhabited the person's body.

The Afrika Museum near Nijmegen has a fine collection of masks. They are very different from each other and indeed often fulfilled very different functions. One of them, for instance, comes from Burkina Faso in West Africa. Not

4 Tyiwara, mask in the form of an antelope,
 Bamana people, Mali, wood, cowrie/turtle shell,
 bead, Afrika Museum, Berg en Dal.

only is this a cover for the head and face, it is also a kind of shield to be held in front of the chest (fig. 3). In this case it isn't the figure of a person which is portrayed, but of a bird. A curious creature, appearing in mythical accounts of these people in which animals or birds often play an important part. The mask was used during the initiation rites of young men. Leaving their settlements, the youths would trek into the bush where they would undergo various rites and ceremonies. One of the adults accompanying them would wear the mask, inspiring awe and dread, and would decide who should undertake which trials.

Then there is another mask in the Afrika Museum resembling a stylized antelope (fig. 4). It comes from Mali, in West Africa. Without knowing anything else about it, you'd assume the object was a free-standing sculpture. Indeed, it isn't worn in front of, but on top of, the head. Photographs taken in Africa show how effectively the strings hanging down from the mask hide the face of the wearer. According to local tradition, an antelope had taught the people of these parts how to cultivate the land. So each year, at the ceremonies connected with the harvest, they gratefully remember the animal. The spiral-shaped groove around the horn represents the growth of the crops, while the crest round the antelope's neck stands for the sun. The idea behind this is evident: the warmth of the sun helps the crops to grow.

Tipsy folk celebrating Carnival in Holland would take one look at the next mask in the Afrika Museum and inevitably think of beer bellies (fig. 5). Actually, it has nothing to do with imbibing beer. It was not a mask to celebrate the delights of Bacchus, but human fertility. The way in which women grow pregnant and bring forth a new human being is considered by the Yoruba of Nigeria to be little short of a miracle. Thus, on the pregnant belly-mask seen here, a triangular pattern has been inscribed, symbolizing wisdom. Although you might assume that such a mask would be worn by a woman, you would be wrong. For even though the mask celebrates the exclusively female powers of reproduction, the privilege of wearing such a wood carving on the torso is reserved for men.

There is only one type of mask in the Afrika Museum that is actually worn by women (fig. 6). It's a solid-looking headdress with wide curved strips round the neck, again connected with fertility and health. The face has a high forehead, with small eyes and mouth. Interestingly, although the mask is intended for women, it presents what is perhaps a male notion of how a woman should appear. Her eyes should be small because it's not her job to look around her and observe things; she has rolls of fat around her neck – a sign of good health; and her tiny mouth suggests that an obedient woman, rather than gossiping nineteen to the

5 Mask in the shape of a pregnant woman's torso,
 Yoruba people, Nigeria, wood, Afrika Museum, Berg en Dal.

dozen, should possess a modest and subdued nature. I wouldn't be very excited at the thought of wearing a mask like this, and I'd certainly think twice before I accepted it – from a man.

6 Sowo wui mask used in female initiation rites,
 Mende people, Sierra Leone, wood, Afrika Museum,
 Berg en Dal.

History on Record

The picture of this despairing woman is burned into my memory (fig. 1). When I saw it first, I wondered, what sort of a painting it was. In fact, it wasn't a painting at all, but a photograph from the World Press Photo exhibition of 1997. Curiously, it is very like many painted history pieces. The Algerian photographer Hocine applied the same principles when he made his prize-winning picture as did the artists who in times past set about recording historical events on canvas. In the Museum of Fine Arts in Brussels you can see the prototype of this type of art. It is *The Dead Marat*, by Jacques-Louis David (1748 – 1825), painted in 1793 (fig. 2). In it, the leader of the French Revolution is portrayed as if he were a martyr, murdered in a cowardly fashion when he was sitting unprotected in his bath. Despite yourself, you are tempted to side with Marat and to assume that his ideas, which gave rise to all kinds of crimes, were as impressive as this portrayal. The artist David was a supreme master in presenting scenes from the past in visual terms and turning them into a political statement. He offered his contemporaries the opportunity to savour headline news as if it were lofty historical tragedy.

In the nineteenth century a school of artists grew up in Antwerp whose main aim was to illustrate history. From the time of the Romantic Movement, roughly speaking the beginning of the nineteenth century, there was a widespread notion that every 'people' or nation was shaped by decisive moments in its own past. The first of the Antwerp painters to illustrate such ideas was Gustave Wappers. There is a picture by him in the Antwerp Musée Royal des Beaux-Arts that will be familiar to every Dutch person (fig. 3). It shows the scene in which two seventeenth-century Dutch statesmen, the De Witt brothers, find themselves in prison, awaiting their fate. The years 1672 was a disastrous one for the Netherlands, and of course the ruling politicians were blamed for everything that went wrong. But why is a scene from Dutch history hanging in a Belgian museum, you may ask? After all, the Belgian provinces had rebelled against the central Dutch government in 1830, and declared their independence. But that explains precisely why the Belgians so enjoyed representing the barbarous behaviour of their neighbours and erstwhile rulers. The De Witt brothers, slaughtered by the howling Dutch mob, were honoured a century and a half later like Belgian heroes. The painting shows the steadfast courage of Jan de Witt in the face of imminent death, and the panic of his brother Cornelis.

1 The Algerian photographer Hocine entered this picture for
 the World Press Photo competition of 1997. Interestingly, it
 has strong similarities with the histories painted by
 nineteenth-century artists.

2 Jacques-Louis David, *The Dead Marat*, 1793,
 oil on canvas, Musée des Beaux-Arts, Brussels.

3 Gustave Wappers, *The De Witt Brothers in Prison*, 1838,
 oil on canvas, Musée Royal des Beaux-Arts, Antwerp.

4 Henri Leys, *Albrecht Dürer Arriving in the City of*
 Antwerp in 1520, 1855, oil on panel, Musée Royal des
 Beaux-Arts, Antwerp.

The history artists of Antwerp concentrated primarily on recording occasions of civic glory from their local past. Henri Leys, a prominent member of the group of painters, made a panel in 1855 showing the visit of the German artist Albrecht Dürer to the city in 1520 (fig. 4). Dürer recorded in his diary that he was given a magnificent reception. Such an occasion was one that every citizen of Antwerp could be proud of.

After all, this was the greatest living artist in northern Europe paying a visit to one of the leading artistic centres of the sixteenth century. Such a moment was a fine opportunity to flaunt a little civic pride.

5 The main hall in the Antwerp museum is fitted out to
 flaunt the glories of the city's past.

In a similar vein, the second half of the nineteenth century saw an impressive series of paintings created in Belgium. No-one less than the Minister of Home Affairs commissioned the artist Niçaise De Keyser to paint them. Initially, the pictures hung in the former Musée Royal des Beaux-Arts in Antwerp. However, it was later decided to build a new home for them with the main hall entirely devoted to displaying this work (fig. 5). On entering the museum, people tend to immediately mount the main staircase, eager to enter the display rooms, but I recommend a little pause before doing this. Stand downstairs in the hall and look up at the freshly restored paintings.

The central canvas is particularly interesting (fig. 6). It represents in allegorical fashion the city of Antwerp. She sits enthroned, flanked by two female figures symbolizing the Middle Ages and the Renaissance. Grouped around this trio are numerous artists from Antwerp. It looks as if the city produced a mighty crop of aesthetically minded offspring, and there are too many of them to name here. Some, of course, are very familiar, such as Peter Paul Rubens, Anthony van Dyck and Jacob Jordaens. The sixteenth century is represented by such well-known painters as Quinten Matsys and Frans Floris. This painting also indicates the relationship of all these artists to each other, that is, who taught whom and who influenced whose work. It is, in fact, a detailed art-historical reference book, but then visual rather than verbal. I myself enjoy looking round the hall of this art museum, sharing in this display of municipal achievement and civic pride. But as I stand admiring, I become aware of a slight sense of unease. Outside this temple devoted to art and history, local politics still beats the drum, with nationalistic panache. Nowadays, Antwerp chauvinism seems somewhat less innocent.

6 Niçaise De Keyser, *Painters and Sculptors of Antwerp* (detail),
 1862-72, oil on canvas, Musée Royal des Beaux-Arts, Antwerp.

A Japanese Passion

If you go past Amsterdam's Van Gogh Museum, you're very likely to see long queues waiting at the entrance, and there are always groups of Japanese visitors among them. Indeed, before 10 am one or two coachloads of eager Japanese art lovers are sure to spill out in front of the museum, anxious not to waste a moment of viewing time. And this continues all day long. It's well-known that the Japanese are extremely fond of Van Gogh's paintings, but not everyone realizes that the artist himself was particularly attracted to Japanese art. When he arrived in Paris in 1887, he was intensely moved by the Japanese woodcuts that he saw

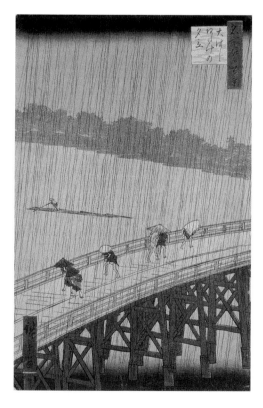

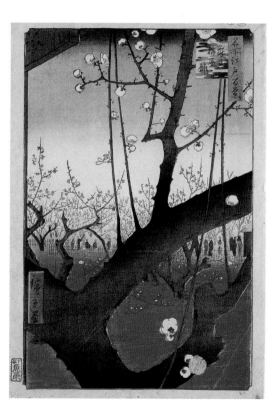

1 (left) Vincent van Gogh, *Blossoming Plum Tree in the Garden of the Teahouse in Kameido*, 1887, oil on canvas, Van Gogh Museum, Amsterdam.

2 Unlike other European artists, Van Gogh was not only inspired by the prints of the Japanese Hiroshige, he also copied them literally.

3 Vincent van Gogh, *The Courtesan*, 1887, oil on canvas,
Van Gogh Museum, Amsterdam.

sible. One of his paintings shows an identical plum tree in blossom as in a print by the Japanese master draughtsman, Utagawa Hiroshige (1797 – 1858), made thirty years before (fig. 1). The Dutch painter was endlessly intrigued by the asymmetrical positioning of the tree and the resulting taut composition. Apparently, he was also fascinated by the Japanese script. Almost as a matter of course, he has brightened up the picture with two colourful bands, one on either side, containing Japanese characters. He copied these from post-cards, for they do not appear in Hiroshige's wood-block print.

The copy of Hiroshige's picture was not to be a one-off event. Van Gogh made copies of other works by the master, including the famous print of a bridge seen in a downpour (fig. 2). This work intrigued not only Vincent, but several other European artists of his day. By choosing a high point of view, the Japanese master created in this and similar pictures a vast sense of space, without relying on perspectival tricks. In the late nineteenth century, Western artists also suddenly took up this method of representing depth in their work without contradicting the essentially flat, two-dimensional character of the painted surface.

While his closest fellow-artists perceived Japan merely as a source of inspiration for their work, to Vincent it meant something far more momentous. He had the feeling in Paris as if

there. At that time, it was the height of fashion to collect this type of what was regarded as 'exotic art'. Van Gogh actually went one step further – not only did he admire the Japanese works, he also copied them as closely as pos-

4 Vincent van Gogh, *The Sower*, 1888, oil on
 canvas, Van Gogh Museum, Amsterdam.

he were surrounded by significant signposts directing him towards that distant country. At the time there was a very trendy French magazine called *Paris Illustré*, and one of its numbers had a cover picture of a Japanese courtesan. The Dutch painter made a faithful copy of this lady of uncertain morals, placing her, as in his earlier Japanese work, within a colourful border (fig. 3). This time his picture was decorated not with Japanese characters but with motifs from nature, frequently found in Japanese prints. Nor was Van Gogh's affinity with Japanese art

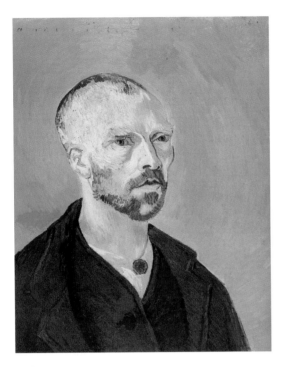

5 Vincent van Gogh, *Self-Portrait as a Bonze*, 1888, oil on canvas, Fogg Art Museum, Cambridge, Mass., USA

Although the content of this painting is reasonably concrete, Van Gogh has in fact created a fairly abstract work. Again, the Japanese influence can be seen in the remarkably flat perspective. The asymmetrical structure of the composition comes largely from the tree in the foreground which leans diagonally across the canvas. Its trunk and branches bleed off the edges of the picture. Like Hiroshige, Van Gogh has rendered the field behind only in broad outline, using vivid colours that do not fade as they recede. Which explains why this landscape suggests above all a sense of space and serves chiefly as the setting for the lone figure of the sower toiling at his work.

Vincent's Japanese passion extended to include far more than just that country's art. Like many people of today, he was attracted by aspects of the Eastern way of life. In 1887 he read a book by the French writer Pierre Loti (1850 – 1923) dealing with Japanese culture. He was particularly attracted by the description of the monks who led a simple life in harmony with the natural world. Van Gogh actually wanted to go to the land of the rising sun and join a community of monks, but things didn't work out that way for him. Instead, he devised a plan to set up a similar kind of community with his fellow artist Paul Gauguin, in the south of France.

Once he'd conceived an idea, Vincent let nothing deter him. Perhaps it's not going too far to say that in this respect some of his fanatic ten-

restricted to his making literal copies of famous works. It influenced all his painting for the rest of his life. A most striking example is *The Sower*, dating from 1888 (fig. 4). The picture is heavy with symbolism. The figure of the sower recalls the pictures of farming people painted by Jean-François Millet in the 1860s and '70s. The large rising sun encircles the head of a farm labourer as if it were a halo. This underscores the message that old-fashioned hard work and being in touch with the soil raises a person to a higher plane, giving them a kind of purity and holiness.

6 Vincent van Gogh, *Flowering Almond Tree*, 1890, oil on canvas,
 Van Gogh Museum, Amsterdam.

dencies became apparent. Having arrived at the chosen spot in France, he set about painting himself in the guise of a Buddhist priest, or bonze (fig. 5). It is a serious, dignified portrait, which he sent to Gauguin by way of a sample, to show that he was really serious in his plans for the monkish brotherhood. But the small community soon came adrift, the two artists quarrelled violently and parted, never to be reunited.

This disastrous incident finished for good Van Gogh's interest in Japan. In his letters not a word more is written about the country.

However, it continued to influence his work right to the very end. The last paintings he made breathe the spirit of that faraway, exotic and fascinating land. His *Flowering Almond Tree*, painted in 1890, would have been quite different had the artist known nothing about the appearance of Japanese prints (fig. 6). Looking at Vincent's work, we begin to understand why the Japanese are so interested in him as an artist. In many of his paintings they see echoed the dimensions of their own great masters.

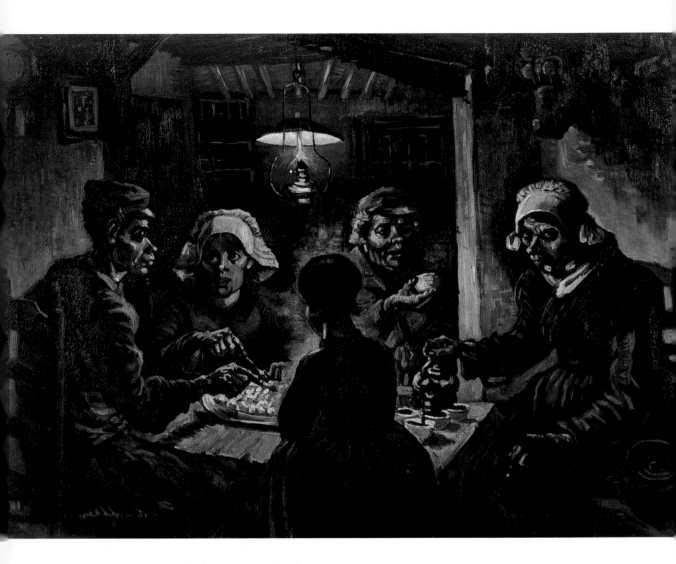

1 Vincent van Gogh, *The Potato Eaters*, 1885, oil on canvas,
Van Gogh Museum, Amsterdam.

Myths about 'Ordinary People'

There are some paintings that almost every Dutch person knows, like Rembrandt's *The Night Watch*. Another such work is Van Gogh's *The Potato Eaters*, which he painted in 1885 (fig. 1). At first, however, it wasn't considered a masterpiece at all. Only with the passage of years has the picture become immortalized. It has been lifted up out of time and history. And as is often the case in such circumstances, there are some very deep-rooted misconceptions about the historical background of the work. Many suppose that Van Gogh created this sombre picture of peasant life to show his deep involvement with these people. They happily forget that representations of this type of simple, honest folk already had a long tradition. More than 25 years previously, the French artist Jean-François Millet (1814 – 1875) had made his name with just such paintings (fig. 2). The style in which he painted was then known as Realism, but in fact what he produced were monumental, meticulously planned compositions showing peasants at work. What Millet wanted to broadcast – just like Van Gogh after him – was a statement about the relationship between people and nature. This had gradually developed into something like a religion. In an increasingly urbanized society many people felt they had lost touch with their roots. Art of this type offered the possibility of rediscovering your origins, of re-establishing that lost contact.

So when he painted *The Potato Eaters*, Van Gogh could draw upon the inspiration of predecessors such as Millet. Evidently, he knew the Frenchman's work, for he had copied a series of his prints onto canvas. In Amsterdam's Van Gogh Museum you can see at least seven such works. Looking at them, you are struck by the fact that Van Gogh seems to have put all his effort into reproducing the industrious activity of the peasants. He has paid far less attention to the background, evidently considering this less important. In this he has not copied the original very faithfully.

The topic of ordinary people seated at table was also quite usual in Dutch painting when Vincent made his famous contribution to the theme. In Amsterdam's Van Gogh Museum there is a painting with a similar subject done in 1882 by the Dutch artist Jozef Israëls (1824 – 1911), who enjoyed great popularity in the Netherlands at that time (fig. 3). When we compare the two works, we understand what a completely new twist Van Gogh has brought to the theme. This was due not only to his unique talent, but also in part to his technical incompetence – he simply couldn't do it any other way. We know from his letters that this painting cost

him an enormous effort and struggle. Vincent planned to make something supremely artistic based on the theme of a few peasants gathered at table. What he finally produced was his first complete 'finished' painting, and he sent it to his brother Theo who was working at an art dealer's in Paris. He was hoping Theo would be able to sell it – but this was somewhat naïve of him. For in those years Paris was in the grip of Impressionism, and the French capital was delighting in paintings of scintillating light. The public there had finally got used to this new style, and Impressionist paintings were doing good business. What did they want with a gloomy picture of gnarled peasant figures sitting in the semi-dark? No one bought Van Gogh's painting.

Vincent tells in his letters how difficult he found it to pull the separate figures into one united composition. Quite frankly, I don't think he succeeded. Despite all his efforts, the figures remain isolated in their individuality. The canvas resembles a collage of separate caricatures, with the individual heads and hands powerfully rendered. Van Gogh made various preliminary studies for these in drawings and oil sketches

2 Jean-François Millet, *The Gleaners*, 1857,
oil on canvas, Musée du Louvre, Paris.

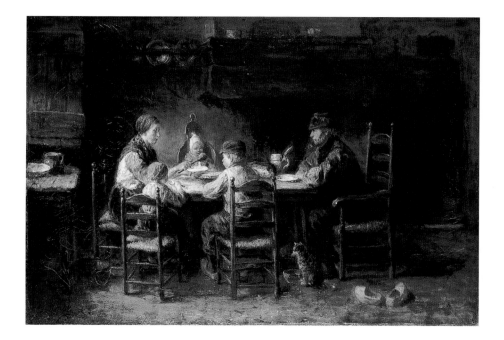

3 Jozef Israëls, *Peasants at Table*, 1882, oil on canvas,
 Van Gogh Museum, Amsterdam.

(fig. 4). But the final picture did not become more than a clumsy collection, a patchwork of painted studies. Even taken on their own, some of the figures are more than a trifle flaky.
All things considered, this painting makes a somewhat curious impression. The five figures are seated together in a room, but each appears frozen in a kind of timeless solitude. There is no communication here. Furthermore, we notice their bizarre eating habits – their meal combines a bowl of potatoes with coffee served in demitasses. Surely a curious mixture, both today and in Van Gogh's time.
Having cracked all these critical nuts, you may begin to wonder when and why people began to appreciate this work. Well, as we saw, no one in Paris wanted the picture, so back it came to Holland. Here too, initially, it met with only negative reactions. Indeed, one critic wrote of it in 1892, seeing it displayed in an exhibition, 'How dare you represent peasants as if they were pigs! Van Gogh, you are little better than a bomb-throwing anarchist.' This outraged reaction reflects once again that painting pictures of peasants was part of a familiar tradition. It was Van Gogh's rather crude, totally unromantic presentation that offended some people. Attitudes only began to change with the

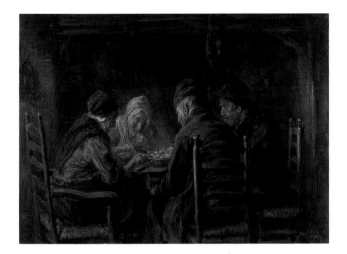

5 Jozef Israëls, *The Potato Eaters*, 1902, oil on canvas,
 Gemeentemuseum, The Hague.

publication of Van Gogh's letters. Then it became clear how he had struggled and sweated to achieve on canvas what he envisioned. In the course of time, *The Potato Eaters* became a kind of manifesto, a declaration of solidarity with the people toiling on the land. Then the picture grew into a symbol for the social misery and poverty of agricultural workers. It was Vincent's personal commentary, and it was hard to imagine anything more lofty and noble. Van Gogh and his painting began to win enormous popular appeal.

There is an interesting little postscript to this story. Vincent died tragically in France in 1890. Twelve years later, the Dutch artist Jozef Israëls painted another picture showing simple folk grouped around a table (fig. 5). They are eating potatoes and some of the faces look remarkably like those in Van Gogh's picture – clearly, the earlier painting had inspired Israëls. This esteemed master of the Hague School of painting, who previously had been Van Gogh's model, now in his old age turned to his pupil for a moment of inspiration.

4 Before he set to work on the painting of *The Potato Eaters*,
 Van Gogh made 'try-out' oil sketches of the heads and
 hands of the people in his picture.

Painter with a Meteorological Bent

Recently, I went for a bike ride along one of Holland's many waterways, the IJssel. As I cycled along, I thought how familiar the landscape appeared. Heavy storm clouds hung over the horizon, rain was imminent, but at the same time there were streaks of sunlight illuminating the sky. Incidentally noticing these things, I realized why the scene looked so familiar.

I'd recently been in the village of Hattem, in the Dutch province of Gelderland, and visited a museum there dedicated to work the of Jan Sr and Jan Jr Voerman. Their paintings reveal skies very similar to what I was seeing on my bike ride. The impression I had gained from studying the pieces in the museum was strengthened by my little jaunt along the water-

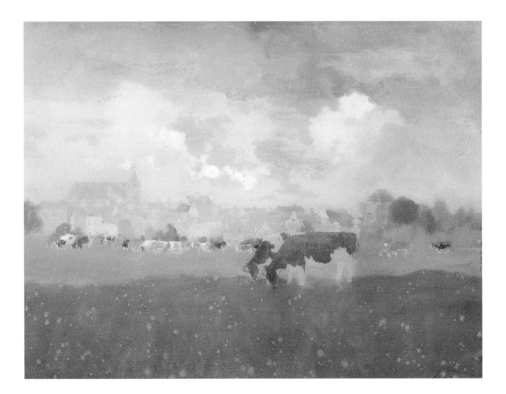

1 Jan Voerman, *View of Hattem*, 1902, aquarelle,
 Voerman Museum, Hattem.

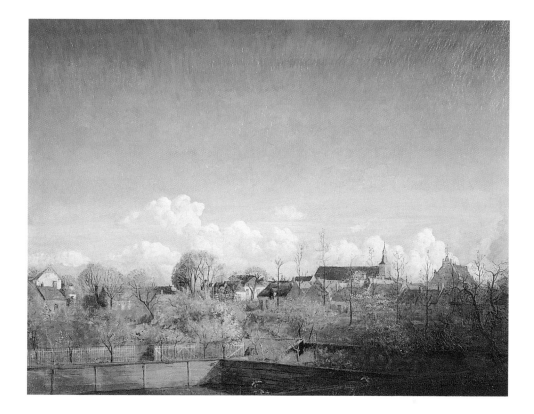

2 Jan Voerman, *View from the Studio*, 1905,
 oil on canvas, Voerman Museum, Hattem.

side. I realized that his work was the result, in
artistic terms, of profound and exacting obser-
vation of natural phenomena. Clearly, he had
made a meticulous study of his local habitation
and transformed his researches into art – some-
thing which is comparatively rare. For most
painters make use of the visible world around
them merely as a kind of springboard for
presenting their own conceptions. It's possible,
I pondered, that this unusual approach of Jan

Voerman Sr accounts for the lack of interest
shown in his paintings by the art-historical
world.

Having completed his studies at the Art
Academies of Amsterdam and Antwerp, the
painter Jan Voerman, who was friendly with
well-known Dutch artists such as George
Breitner and Floris Verster, had a spell produc-
ing Impressionistic cityscapes, interiors and
flower still lifes. Towards the end of the 1880s

3 Jan Voerman, *Meadow Landscape in Summertime*, by the
 IJssel, n.d., oil on canvas, Voerman Museum, Hattem.

he settled in the village of Hattem, in Gelder-land, so that he could concentrate on landscape painting. It was a time when artists commonly left the city for the countryside, in search of the purity of the rural setting. But unlike many others, Voerman, attracted by the beauty of nature, was to remain living in the country for the rest of his life.

An aquarelle he painted in 1902 shows that initially his work was highly stylized (fig. 1). The picture is composed of strictly defined zones and shows little spatial perspective. Indeed, the meadow in the foreground with its evenly distributed buttercups and piebald cows displays a designer's touch. The silhouette of the village of Hattem, seen against the skyline, looks just a little 'arty'. This work, and in particular the atmosphere it exudes, fits in with the European art movement of the previous decades. In France the group known as the Nabis, founded in 1888, adopted a poetic manner of painting using areas of colour and a stipple technique.

4 Jan Voerman, *View over the IJssel*, n.d., oil on canvas,
Voerman Museum, Hattem.

Their French members included Pierre Bonnard and Edouard Vuillard, while Willibrord Verkade, who happened to be Voerman's brother-in-law, was closely associated with the group, introducing this style of painting into the Netherlands. Back to Voerman's picture, where we notice that in the zone above the buildings of Hattem the artist has adopted a new tactic. Indeed, here we feel that he has painted from direct observation. The clouds, which are actually the least tangible of all the elements that surrounded the painter, are given a powerful plasticity, contrasting strongly with the other sections. In his later work the artist also presented the landscape with detailed precision. There is a canvas dating to 1905 which shows precisely what Hattem looked like as seen from his studio (fig. 2). To judge from the quality of the light that illuminates the houses and the trees whose leaves are just starting to shoot, it must be a brilliant morning in spring. Again we notice the strength of this artist's affinity with the weather.

5 When art historians haven't a word to say about the
paintings of Jan Voerman Sr, Dutch TV weather forecaster
Erwin Krol has a whole story to tell about the picture.

Evidently, for him the ultimate challenge was
to represent the atmospheric circumstances
he perceived.

He did this in various ways. Sometimes he
produced a tonal piece that harks back to the
work of the Hague School of painters.
However, it's noteworthy that above many
of these landscape views a huge sky reigns,
packed with clenched clouds that have a drama
unequalled in Dutch art. These paintings are in
fact unique documents (fig. 3). Indeed, in one
case a canvas records a specific meteorological
incident. In 1925 there was a violent storm over
the village of Borculo, near Hattem, and the sky
glowed a fiery red – inspiration for a painting

by Voerman. But generally speaking he didn't
require such exceptional scenes. The nature
surrounding him every day was inspiration
enough.

The scene that I recalled on that bike ride
contains nothing more extraordinary than
what you'd see most days (fig. 4). That is, if
you were looking with an artist's eye. I wanted
to find out a little more about these remarkable
scenes, and that asked for someone with a
different expertise than an art historian's.
So I got in touch with Holland's best-known
TV weather forecaster, Erwin Krol, who is a
meteorologist (fig. 5). This is what he had
to say:

'While this painting leaves art historians without a word to tell, for me as a weather forecaster, it contains a whole fascinating story. When the sun sinks at the end of a warm clear summer's day, the earth grows colder. Warm air masses rise, to grow cooler once they are in the atmosphere. Where you have a sizable stretch of water like the IJssel, a great deal of moisture rises and then condenses as soon as the temperature drops. This creates what we call cumulus clouds which can fill the sky with their huge curling shapes, often majestic in their architecture. The moment comes when a cloud is saturated with water and can hold no more. Then the moisture falls as rain. That's when everyone rushes indoors, taking cover from the downpour. But actually, you should stay outside and watch. High in the sky you will see the reflection of the sunlight, while low on the horizon it grows dark purple-grey with maybe a display of skittish lightning flashes. And for those who can't bear the thought of getting wet, Jan Voerman has given us a magnificent painting of just such a scene. I find this one of our most spectacular summer sons et lumières shows, and all for free.'

Analyzing Self-Portraits

During his short career as a painter, Vincent van Gogh made at least thirty-five self-portraits. Many people who know something about him won't find this very surprising. After all, they will say, he was always obsessed with himself. Looking at one of the self-portraits, some people only want to know if this was before or after the mythical slicing-off of Vincent's ear. In Amsterdam's Van Gogh Museum one showcase presents five small canvases which are self-portraits. The spectator who is obsessed with Vincent's ear will be rather disappointed in these for they reveal, alas, nothing of that despairing deed. The viewer who spends a little longer looking at these pictures will be rewarded by discovering that they have many other fascinating aspects. The earliest self-portrait in the museum collection dates from 1887 (fig. 1). Vincent, recently arrived in Paris, couldn't afford to pay a model, but managed to acquire a mirror. So he became his own subject. The canvas wasn't created as an independent work of art, but intended for experimentation. On the reverse is a preliminary study for *The Potato Eaters* and presumably Van Gogh was testing how best to represent a person's expression and the direction of gaze. Practice makes perfect, and it was by experimenting that he would discover the best way of positioning a head in the picture plane.

After his arrival in Paris, Vincent tended to use less gloomy colours than he had done in the Netherlands. Nevertheless, heavy tones continue to dominate. He tried hard to create a style for himself in contrast to his contemporary artists. At that time many painters, inspired by the Impressionists, created their compositions against a light background. Van Gogh preferred to use one that was dark. Wishing, however, to project a feeling of strength and vitality, he felt obliged to use strongly contrasting pigments. His vivid use of colour achieved a variety of results. The showcase in the Van Gogh Museum contains a study in which his head truly looms up out of the darkness (fig. 2). When he needed a model for portrait painting, there was one other group of people that Van Gogh could call upon, apart from having recourse to himself. He could just scrape together the money needed to pay a prostitute to sit for him, at an hour otherwise unprofitable for her profession. There is a fine example of such a portrait in the museum, painted with swift brushstrokes, and dating to 1885. It shows a young woman with her hair hanging loose about her shoulders (fig. 3). Van Gogh cherished the naïve idea that she would be able to attract clients by hanging the portrait above her bed. But it seems doubtful that this simple mar-

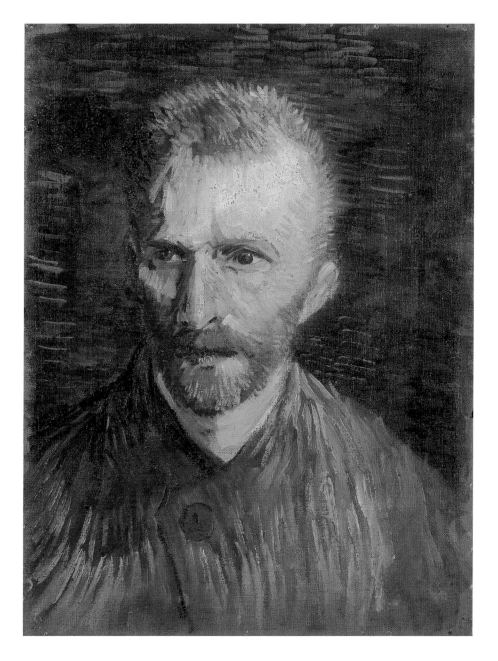

1 Vincent van Gogh, *Self-Portrait*, 1887, oil on
canvas, Van Gogh Museum, Amsterdam.

3 Vincent van Gogh, *Head of a Girl with Hair Hanging Loose*,
1885, oil on canvas, Van Gogh Museum, Amsterdam.

self-portrait as a sales gimmick. Even the painterly style suddenly receives a lightly Impressionistic touch – at least, that's what Van Gogh intended when he painted this self-portrait. His letters tell us another touching detail – apparently he had been to the dentist for the first time in ages, wishing to appear presentable on the off-chance that a client might appear. From some of Van Gogh's work, we can see how he followed with great interest the developments taking place in his chosen profession. One of the self-portraits in the Van Gogh Museum echoes the style of Paul Signac, Vincent's fellow artist and friend (fig. 5). Instead of mixing the paints on his palette, Signac developed the method of painting short brushstrokes and stipples of differing tones beside each other. This created a dazzling effect on the canvas, producing a shimmering sensation intended to echo the visual experience. After all, the eye doesn't perceive the world around us in mixed hues, but rather as particles of light, broken into the colours of the spectrum. Van Gogh adopted this technique, but not because he was in love with the theory it represented. By using it, he added weight to his expression and linked the style of brushstroke on his face with the background, to form one painterly unity.

keting method would prove very profitable. Buyers didn't flood in to scoop up Vincent's paintings, so he was constantly puzzling over new ways of peddling his work. On one occasion this had a direct influence on what he painted. Wanting to demonstrate that he could paint other figures besides himself, he got himself all dolled up before he sat down, palette in hand, in front of his easel and mirror (fig. 4). With his felt hat and fashionable jacket, he transformed himself into a Parisian dandy:

2 Vincent van Gogh, *Self-Portrait with Straw Hat*, 1887,
oil on canvas, Van Gogh Museum, Amsterdam.

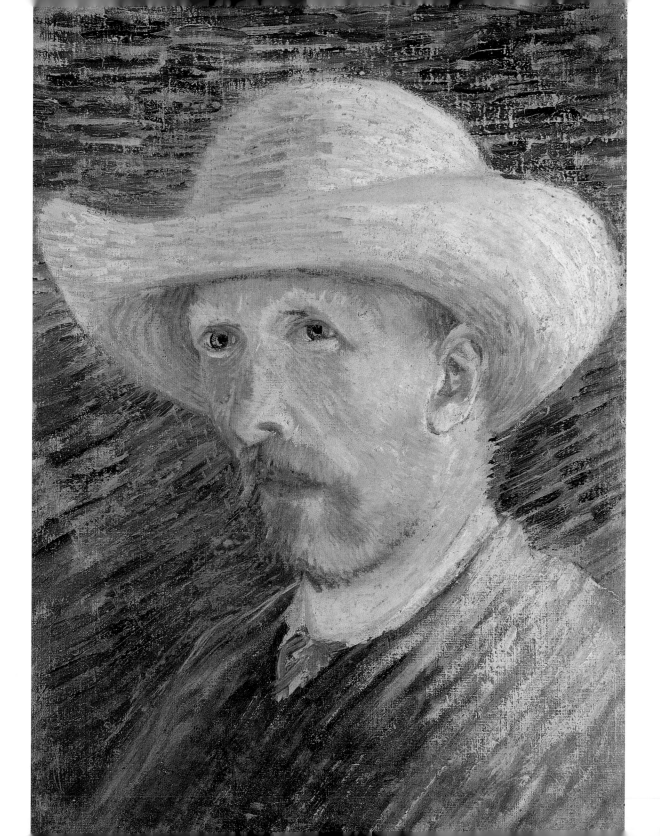

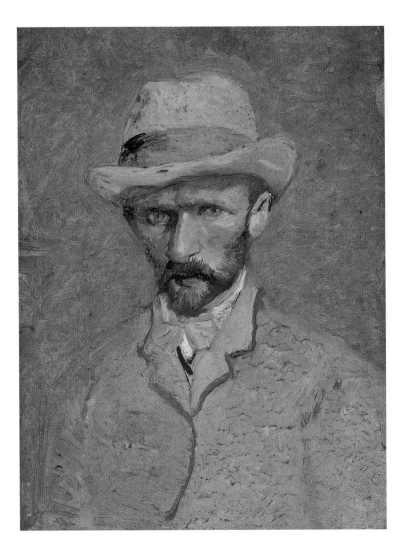

4 Vincent van Gogh, *Self-Portrait with Grey Felt Hat*, 1887,
 oil on cardboard, Van Gogh Museum, Amsterdam.

Only one of the self-portraits in the Van Gogh Museum is signed by the artist, signifying he considered it to be a finished work (fig. 6). He considered this large painting as a true mirror of the soul. Holding his artist's equipment at the ready, he stands beside his easel, proud and vigorous – at least, so it would appear. Evidently, however, it is difficult to diagnose Vincent's mental state from looking at his self-portrait. At all events, I apparently lack

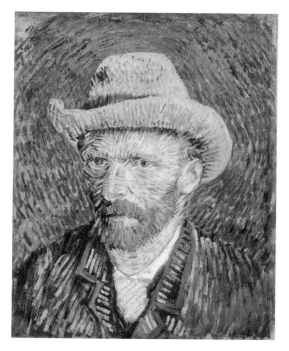

5 Vincent van Gogh, *Self-Portrait with Felt Hat*, 1887, oil on canvas, Van Gogh Museum, Amsterdam.

you can truly appreciate them. And not only that – it's good to remember that they were often made for very prosaic purposes, to earn some much needed cash.

the sensitive feelers required, for from the documentation about this picture, we learn a very different story. In one of his letters, Van Gogh said that he had finally succeeded in portraying convincingly his sense of total desperation.

I don't need to tell you that I find these self-portraits in the Van Gogh Museum exceptionally intriguing. One reason is that their status and significance aren't immediately obvious, and are ever-changing. These works are highly personal statements, and you need to know something about the man and his life before

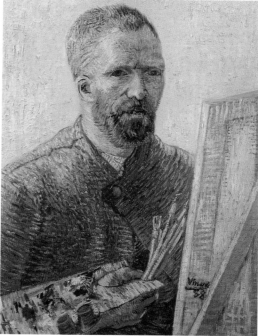

6 Vincent van Gogh, *Self-Portrait as a Painter*, 1888, oil on canvas, Van Gogh Museum, Amsterdam.

Household Design

Over the past few years some artists have taken the slogan 'total design' utterly seriously. Famous names such as Alessandro Mendini or Philippe Starck get involved with designing literally anything, and the public expects it of them, too. To make a name for themselves, designers of today must have a vision about the shape of a toilet brush (fig. 1). And if you think such objects are beneath your dignity, woe betide you! Many will assume this passion for interior furnishing is a very modern tendency, and to a certain extent this is so. In the 1970s and '80s people acquired quantities of objects which they crammed into their dwellings, without much caring what things looked like. The discerning assure us that this simplistic attitude will no longer do. Although a hybrid style is permitted, you should plan your interiors with care and consideration, and acquire articles that bear witness to excellence of design. The latter is far from being a new phenomenon. Even in the late Middle Ages, the interiors of dwellings and the objects they contained were thoughtfully designed. Paintings by the fifteenth-century Flemish masters amply illustrate this. They frequently reflect in remarkably intricate detail the insides of houses and homes where daily life was acted out.

In New York's The Cloisters, the medieval section of the Metropolitan Museum, there is a Flemish painting known as the Mérode Altarpiece (fig. 2). This superb triptych was painted by Robert Campin around 1425. He was the teacher of the Flemish painter Rogier van der Weyden and also inspired the great artist Jan van Eyck. The central panel of this triptych represents the Annunciation, when the Angel Gabriel told Mary she would be the mother of the son of God. The scene here has a somewhat unusual setting, being placed in a house which clearly belongs to a wealthy burgher of the Low Countries. Thus, Campin gives his client every possibility to identify with the scene. And incidentally, for us, the room is a mine of information about the interior furnishings of the time. We see with what skill the craftspeople of those days produced fittings and furniture.

Strange to say, not many art historians pause to consider this aspect. Having asserted that the objects on view are drawn with consummate realism, they become submerged in a turgid debate about the exact symbolism of the various items on show. Countless experts have devoted themselves to explaining questions relating to

1 Famous designers such as Alessandro Mendini or Philippe Starck didn't consider it beneath their dignity to create such trivialities as a brush for cleaning the toilet.

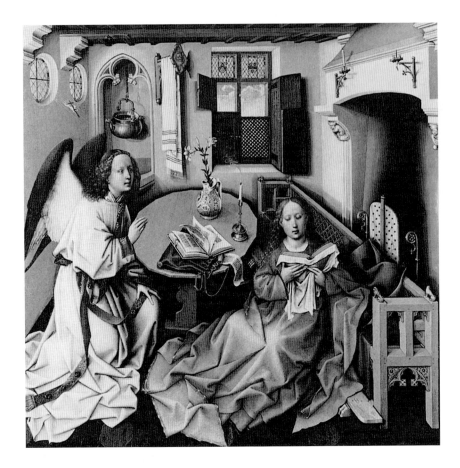

2 Robert Campin, *Mérode Altarpiece*, c. 1425, oil on panel,
 The Cloisters/The Metropolitan Museum of Art, New York.

the significance of these articles. The candle-stick, for example, is not just to provide light so that Mary can read her book more easily; no – the candle is a reference to her virgin purity. And so forth. Using literary and other historical sources, any of the objects seen may be discussed, defined and (re)interpreted. But let's forget that for a while and concentrate on the objects themselves, rather than their symbolism.

The room is filled with remarkable furnishings. Very little remains today of such medieval objects, though once they must have been plentiful enough. But domestic ware, then as now, would be thrown away when it grew out of fashion or was no longer useful – never mind the

3　Gysbrecht Stryck, Towel rack, 16th century, oak, Sankt Viktor, Xanten.

for this purpose, such as a liturgical comb so that he could tidy up his hair. And this towel rack held the cloth used to dry his hands after the ritual washing.

The towel rack in Xanten is, globally speaking, quite similar to the one in the Mérode painting in The Cloisters. Both have a flat, richly carved disc at one end, the only difference being in the ornamentation. The painting in New York reveals the features of a human face on the towel rail, while that in Xanten is carved with plant motifs. This is typical of late Gothic decoration and refers to organic growth. Beneath the curling leaves is the shape of a pelican with its young, an unequivocal reference to Christ's sacrificial death. The pelican, so the story goes, would peck at its own breast to feed and nourish its young with its own blood. On the long side of the towel rail there are peacocks, symbol of eternal life. Finally, on the lower section of the part that is fastened to the wall is the seductive shape of a little mermaid.

The most fantastic towel rack I've ever set eyes on is presently not so far from Xanten, in the Kurhaus Museum of Cleves (fig. 4). Master Arnt van Tricht, the maker, clearly pulled out all the stops in creating this sensationally comical piece of visual entertainment. We see a shapely dame holding in both hands the rail from which the towel can be hung. Snuggling up to her is a man dressed in jester's garb, evidently having a fine time stroking her feminine

quality of the decoration. There is a towel rack in the Campin painting that looks splendid, but today only a couple of such items have been preserved. In the German cathedral town of Xanten, not far from Nijmegen on the Dutch-German border, several miles down the river Rhine, there is a towel rack which once served a noteworthy purpose (fig. 3). It was customary in the Roman Catholic church, before beginning the ceremony of the Mass, for the priest to ritually purify himself, according to a strict protocol. Church buildings provided special facilities

4 Master Arnt van Tricht, Towel rack, 1540, wood,
Kurhaus Museum, Cleves.

curves. She is not in the least disturbed by his advances. Clearly, they are about to indulge in a session of heavy petting. Perched on each of their shoulders, the couple has a tiny jester's figure playing a musical instrument, while a third such clown pokes his head through the fashionable slit in the man's sleeve.

This ingenious piece of wood carving in the Cleves museum demonstrates that in the sixteenth century there were skilled craftspeople who, just as today, created objects that were aesthetically pleasing as well as being functional. Like Starck and Mendini, Master Arnt also seems to have had a great sense of humour.

Maybe someone would be interested to know if a guy like this also designed toilet brushes. There I have to disappoint the eager enquirer – such things didn't yet exist in the sixteenth century.

A Painter's Symbol

Hear the name Van Gogh and you think of sunflowers (fig. 1). You can't miss reproductions of his famous painting, available in all sorts and sizes in shops selling posters and cards or general souvenirs, not to mention in art museums. You can find the picture on sedate school walls, in business blocks and in sports club canteens. Lots of people hang them in their homes. There's scarcely a spot where they wouldn't look good. Sunflowers, sunflowers everywhere. The picture has become so familiar that you never stop to ask how and why did the artist paint it? What did sunflowers mean to Vincent?

His career as an artist was remarkably short, but he managed to paint 11 pictures of sunflowers. In Amsterdam's Van Gogh Museum there's a small panel dating from 1887 which shows these flowers looking quite different from how we know them in the famous reproductions. None of your burning colours and dancing shapes rising out of a vase, but two sad wilted corpses lying against a dark background. Van Gogh was experimenting, trying out ways of representing the plasticity of the plant, seen from various angles.

This rough oil sketch finally developed into a large work that presently hangs in the Kröller-Müller Museum in Otterlo (fig. 2). In the background right is the head of a flower seen in reverse, which the artist had patiently copied and worked on. Beside it lie three flowers with

1 Vincent van Gogh, *Vase with Sunflowers*, 1889, oil on canvas, Van Gogh Museum, Amsterdam.

their faces turned towards the spectator, edged with their circlets of wavy petals. The contrasting colours take us by surprise and bring a remarkable visionary quality to this painting. The flower still-life painting was a well-estab-

2 Vincent van Gogh, *Four Cut Sunflowers*, 1887,
 oil on canvas, Kröller-Müller Museum, Otterlo.

lished genre in art by the time Van Gogh
arrived, but he has given it a new dramatic
content.

In spring 1886 Vincent went to Paris, where he
met the artist Paul Gauguin in November of
that year. The latter had just relinquished a suc-
cessful career as a businessman in order to
devote himself entirely to art. He had already
acquired a considerable reputation amongst his
fellow artists. Nevertheless, he was profoundly
impressed by the sunflower paintings of the
relative newcomer, Vincent van Gogh. Indeed,
he liked two of the pieces so much that he
exchanged them for some of his own work.

In the autumn of 1888, Vincent, now settled in
Arles in the south of France, waited eagerly for
the arrival of his friend Gauguin. He looked
upon the French artist as a kindred spirit and
planned to live in a kind of commune with him.
He wanted to prepare a fitting welcome for

Gauguin and decided to decorate his room with paintings. Around the town of Arles the fields were full of sunflowers, and so it was that Van Gogh found his subject. Totally absorbed, he painted away, producing four pictures, two of which he felt would do. He hung them on the wall, something like welcoming bouquets of flowers. These two canvases are presently in the Neue Pinakothek in Munich and the National Gallery in London.

While he was staying in Arles, Paul Gauguin painted a portrait of Vincent (fig. 3). The latter thought it was a frightful picture because he felt it showed him looking like a madman. That's

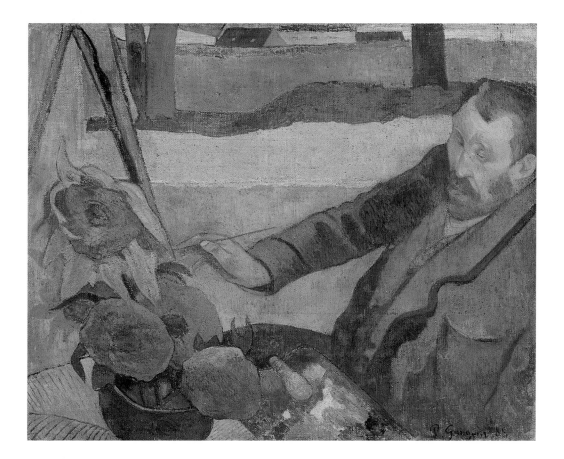

3 Paul Gauguin, *Van Gogh Painting Sunflowers*, 1888, oil on canvas, Van Gogh Museum, Amsterdam.

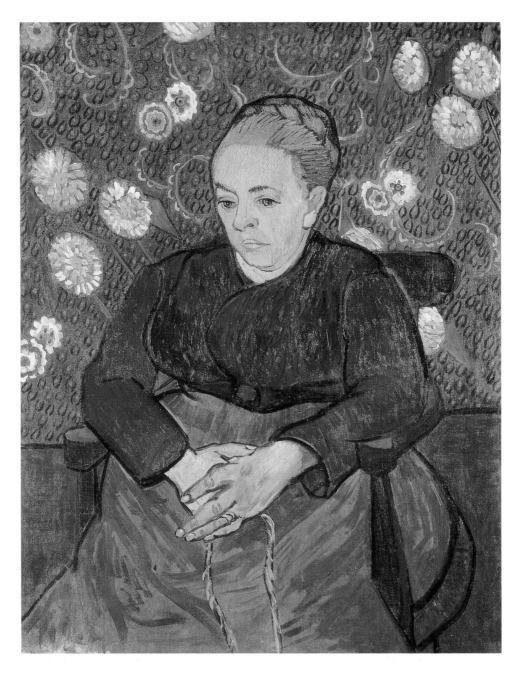

4 Van Gogh envisioned the painting of *La Berceuse* flanked by
two panels showing sunflowers.

not relevant at this point – what I'm concerned with now is how the artist is immortalized – as a painter of sunflowers. Thus, we see that Van Gogh is associated with this theme long before the mass reproduction of his work took off. Gauguin already showed the link between the Dutch artist and the golden flowers.

About six months later, in the winter of 1889, all contact between Vincent and Gauguin was broken off following a violent quarrel. Nevertheless, Van Gogh again became inspired by a happy event that brought him great delight. The wife of the postman of Arles, Madame Roulin, for whom he felt enormous affection,

had a baby. Vincent was deeply moved by this, and just when his colleague was coming to Arles, he wanted to express his emotion in an uplifting, grand gesture. So he conceived the idea of painting a picture of the mother. He wanted this to exceed the ordinary, to soar as it were far above the everyday mundane portrait, to possess an almost religious charisma.

The painting of Madame Roulin, which Vincent called *La Berceuse*, meaning the woman rocking a cradle, now hangs in Amsterdam's Van Gogh Museum. The artist's original plan, however, was for it to form the central panel of a triptych. In one of his letters, Vincent drew a sketch of

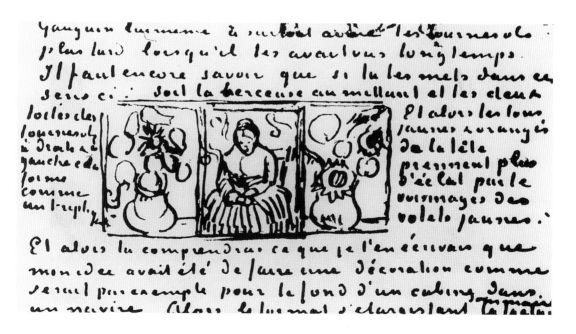

5 One of Van Gogh's letters has a sketch of how he saw the
 triptych with the sunflower panels.

6 For the catalogue cover of the first Van Gogh exhibition ever held, Richard Roland Holst designed a wilting, broken sunflower, symbolic of the artist's career.

exhibition catalogue (fig. 6). It is a moving tribute. His woodcut shows a drooping sunflower with a crooked halo round its bent neck, a tragic symbol for Vincent's career. Like the plant, he grew fast and tall, only to fade and wilt. The identification of the artist with his beloved theme is now complete.

how he envisioned this work: the portrait would be given side wings, both of them rejoicing in sunflowers (figs 4 & 5). The only trouble was, there were no sunflowers blooming at that time of year. So Van Gogh copied the paintings he had made for Gauguin's room, adapting them as side panels for his new work. The painting of the sunflowers that is so familiar today from the Van Gogh Museum collection, was initially one of the wings for the triptych of *La Berceuse*. After Van Gogh's death in 1890, sunflowers were planted upon his grave. Two years later, the first exhibition entirely devoted to his work, took place in Amsterdam. The Dutch artist Richard Roland Holst designed the cover for the

Fundamental Feelings

In 1893 the Norwegian artist Edvard Munch (1863 – 1944) made a painting known throughout the English-speaking world as *The Scream* (fig. 1). This masterpiece is timeless. It speaks to people about their fundamental fears. Munch has painted the anguish of an archetypal nightmare. You want to cross over a bridge because it looks attractive on the other side. A warm glow lures you. Other people are making the crossing ahead, but for some reason you stand frozen. The way is blocked by a horrible screaming shape, a monstrous form fabricated by your own fears. Munch's picture has been endlessly reproduced, not only in every imaginable size in two dimensions, but even as an inflatable companion (fig. 2).

Something as ridiculous as this can only work and be financially viable if the public has fallen under a spell. And apparently almost everyone recognizes the primeval cry of anguish pictured in *The Scream*. Following in Munch's footsteps, many modern masters have tried to express this kind of fundamental feeling in their paintings. Indeed, in the twentieth century it became a kind of standard subject. A specialist in this field from the Low Countries is the Belgian painter, Constant Permeke (1886 – 1952), although he didn't deal in nightmares. In Het Nijenhuis Castle, Heino, in the Dutch province

of Overijssel, the Hannema-de Stuers Foundation has several powerful paintings by Permeke from the first quarter of the twentieth century.

The Belgian artist, master of many techniques from drawing to sculpture, lived in a society dominated by poverty and deprivation. Not surprisingly, these subjects inform his work. The picture of the man eating porridge was painted around 1919 and is characterized by a sober composition and raw style (fig. 3). On the left sits a doleful figure consuming his frugal meal while beside him is a dog who appears, if possible, even more miserable. While the scene illustrates the extremely primitive living conditions of the man, it also makes a wider statement. In the nineteenth century, the lives of poor folk were painted by the so-called salon artists. They presented the raw, rough reality in a refined and frequently sentimental manner. Permeke wanted to achieve something quite different. He adapted his working method to the subject in hand and brought a huge intensity and concentration to his pictures. You can almost feel the electric power sparking off the canvas. Permeke's involvement in the deeper tensions of life was closely connected, as it was for many of his colleagues, with his experiences in World War I. This futile and inane conflict, introduc-

2 The screaming shape in Munch's picture speaks widely to
 people, and it has even been transformed into an inflatable
 version.

ing the most barbaric weapons to the war sce-
nario, brought untold destruction to Europe,
and left millions dead. It looked as if European
civilization was almost at an end.

The artists of the time wondered hesitantly if
there was any place left for them and their
work. Some decided to concentrate on depicting
the fundamental human passions, which
seemed to account for the turmoil and chaos
which surrounded them. They believed they
could base both the content of their work
and its visual language on these themes.

Painting should get back to basics.

Like most of the men called up for military
service, Permeke experienced the war first
hand. He joined the Belgian infantry, but his
active involvement proved short-lived for he was
seriously wounded by enemy fire and transport-
ed to England together with other victims.
There he was hospitalized and given medical
treatment. Disguised as a nurse, his wife
sneaked across the English Channel and
managed to join him in the hospital. There is
a painting in Het Nijenhuis Castle collection

1 Edvard Munch, *The Scream*, 1893, oil on canvas,
 Munch Museum, Oslo.

3 Constant Permeke, *Man Eating Porridge*, c. 1919,
 oil on canvas, Het Nijenhuis Castle (Hannema-
 de Stuers Foundation), Heino.

documenting the couple's English sojourn
(fig. 4). It shows a man and a woman seated on
a bench beneath a tree in the evening sunlight.
Presumably, the painter wanted to record an
impression of what life was like for him at that
time. It's hard to be certain about this, for the
faces of the couple lack any recognizable fea-
tures. In Permeke's art, reality as such plays
only a minor role. He was inspired by the urge
to express his motifs, either using paint or
other materials.

There is another painting by him in the Heino

4 Constant Permeke, *True Stories*, 1916, oil on canvas,
 Het Nijenhuis Castle (Hannema-de Stuers Foundation), Heino.

museum, showing a landscape (fig. 5). The grass has been mown, and farmhands are busy piling it onto carts. This warm summer scene looks a good deal more cheerful than much of Permeke's other work. But this picture, too, uses the same approach. There is no detailed rendering of items. Rather than going outside with his palette, the artist painted the picture inside his studio. Trees, bales of hay, clouds – all are carefully arranged contours. 'I paint with my eyes shut,' he once formulated it, indicating in a poetic way that for him

5 Constant Permeke, *The Harvest*, 1917, oil on canvas,
 Het Nijenhuis Castle (Hannema-de Stuers Foundation), Heino.

there was no question of copying reality.

My favourite painting by Permeke doesn't hang in Heino, but in Amsterdam's Stedelijk Museum (fig. 6). It is a winter view of the little place of Aartrijke, near Sint-Martens-Latem, in the Belgian province of West Vlaanderen, painted in 1921. At one time, a small group of artists formed a colony there; but then the First World War broke out, and life changed. The buildings clustered round the centre of the village are outlined with strong thick brushstrokes which substantially create the mood of the picture. This large canvas with its dark rich colours has a kind of magic about it. Like Edvard Munch, Permeke was fascinated by the fundamental feelings that motivate human behaviour and lie scarcely buried beneath a civilized surface. Time and again he tried to express this in his art. And indeed, his work is compelling: it is hard to turn aside and walk away.

6 Constant Permeke, *View of Aartrijke*, c. 1921,
 oil on canvas, Stedelijk Museum, Amsterdam.

Index of illustrations

The index provides a list of the illustrations in the book, showing art objects in public museums. The collections are listed alphabetically by place and museum. The works of art are listed alphabetically under the artist's name. In the case of some artists, several works from one museum collection are illustrated. These are then listed chronologically in the index.

Jacob van Ruisdael, *View of Haarlem with the Bleaching Fields*,
c. 1670-75, oil on canvas, 55.5 x 62 cm, p. 54
Rogier van der Weyden, *The Lamentation*, c. 1450, oil on panel,
80.6 x 130.1 cm, p. 67

Hamburg, Museum für Kunst und Gewerbe
Gregor Erhart, The Infant Christ Holding the World Orb, c. 1500,
polychromed limewood, h. 56.5 cm, p. 137

Hattem, Voerman Museum
Jan Voerman, *View of Hattem*, 1902, aquarelle, 30 x 40 cm, p. 182
View from the Studio, 1905, oil on canvas, 69 x 90.5 cm, p. 183
Meadow Landscape in Summertime, by the IJssel, n.d., oil on
canvas, 31 x 52 cm, p. 184
View over the IJssel, n.d., oil on canvas, 31.5 x 51.5 cm, p. 185

Heino, Het Nijenhuis Castle (Hanema-de Stuers Foundation)
Constant Permeke, *True Stories*, 1916, oil on canvas,
76 x 102 cm, p. 209
The Harvest, 1917, oil on canvas, 72 x 92 cm, p. 210
Man Eating Porridge, c. 1919, oil on canvas, 60.5 x 65.5 cm, p. 208

Leiden, National Museum of Antiquities
Panathenaic amphora, c. 530 BC, earthenware, h. 66.5 cm, p. 95
Hydria, a water jug, showing a scene in the baths, c. 520 BC,
earthenware, h. 66.5 cm, p. 97
Etruscan kantharos, 6th century BC, earthenware, h. 12 cm,
diam. 12 cm, p. 95

London, Wallace Collection
Peter Paul Rubens, *The Adoration of the Magi*, 1624, oil on panel,
63.5 x 48.3 cm, p. 142

Maastricht, Bonnefantenmuseum
Head of John the Baptist, Nottingham, late 15th century,
alabaster, h. 32 cm, p. 30

Madrid, Museo del Prado
Rogier van der Weyden, *The Descent from the Cross*, c. 1440, oil
on panel, 220 x 262 cm, pp. 68-71

Munich, Galerie im Lembachhaus
Franz von Stuck, *Salome*, 1906, oil on canvas, 121 x 123 cm, p. 33

Namur, Musée des Arts Anciens, Namen
A cradle for Baby Jesus, Liège, c. 1400, silver gilt,
12.6 x 12 x 8 cm, p. 135

New York, The Cloisters/Metropolitan Museum of Art
Robert Campin, *Mérode Altarpiece*, c. 1425, oil on panel,
64.3 x 62.9 cm (middle section), 64.5 x 27.4 cm (panels), p. 196

Oslo, Munch Museum
Edvard Munch, *The Scream*, 1893, oil on canvas,
83.5 x 66 cm, p. 206

Otterlo, Kröller-Müller Museum
Lucio Fontana, *Concetto Spaziale Nature*, bronze balls,
diam. 92-110 cm, p. 16, 17
Vincent van Gogh, *Four Cut Sunflowers*, 1887, oil on canvas,
60 x 100 cm, p. 200
Ian Hamilton Finlay, *Five Columns for the Kröller-Müller; or a Fifth
Column for the Kröller-Müller; or Corot Saint-Jus*, 1980-82,
installation with five stone socles, p. 39
Chaim Jacob Lipchitz, *The Couple*, 1928-29, bronze,
92 x 168 x 96 cm, p. 37
Aristide Maillol, *Air*, 1939, lead, 140.5 x 234 cm, p. 36
Arturo Martini, *Judith and Holofernes*, 1932-33, stone,
h. 240 cm, p. 38
Marta Pan, *Floating Sculpture 'Otterlo'*, 1960-61, polyester,
226 x 183 x 216 cm, p. 39
Constant Permeke, *Niobe*, 1951, bronze, 100 x 260 cm, p. 36
Auguste Rodin, *Crouching Woman*, 1882, bronze,
95 x 52 x 66 cm, p. 35

Paris, Musée du Louvre
Jean-François Millet, *The Gleaners*, 1857, oil on canvas,
84 x 112 cm, p. 178

Paris, Musée d'Orsay
Jean-François Millet, *l'Angélus*, 1857-59, oil on canvas,
55 x 66 cm, p. 75

Paris, Musée Rodin
Auguste Rodin, *The Prodigal Son*, 1885-87, bronze,
h. 270 cm, p. 82

Rome, Santa Maria del Popolo
Michelangelo Merisi di Caravaggio, *Martyrdom of St Peter*,
c. 1600, oil on canvas, 340 x 350 cm, p. 111

Rotterdam, Museum Boijmans van Beuningen
Francis Bacon, *Fragment of a Crucifixion*, 1950, oil on canvas,
139 x 108 cm, (on loan from the Municipal Van Abbemuseum,
Eindhoven), p. 114

The copyrights for other works illustrated in the book are held by the following:

p. 19	Louis van der Vuurst, Uithoorn
p. 23 (fig. 2)	Iveagh Bequest, Kenwood, London
p. 24	René Gerritsen, Amsterdam
p. 31 (fig. 1)	(Hinrich Funhof: Gastmeal of Herod, 1483; Lüneburg, Johanniskirche) Photo studio W. Krenzien, Lüneburg
p. 31 (fig. 2)	Glasgow Museums; The Burrell Collection, Glasgow
p. 46 (fig. 3)	(Great Panhagia, Virgo Orans of Yaroslav, 12th century) Tretyakov Gallery, Moscow
p. 62	Staatliche Kunstsammlungen, Dresden
p. 64	Reconstruction according to Oertel, from: Italiaanse schilderijen 1300-1500. Own Collection Boijmans van Beuningen, 1993, p. 96
pp.69-71	Reflectograms (IRR Computer mounting). Prof. dr. J.R.J. Asperen de Boer, Amsterdam / Rijksbureau voor Kunsthistorische Documentatie, Den Haag
p. 76	Private Collection
p. 88	Maarten Corbijn, Amsterdam
p. 94	Louis van der Vuurst, Uithoorn
p. 96	Jan-Maarten Hupkes, Amsterdam
p. 98	Wedgwood Museum, Staffordshire
p. 99	Windsor Castle, Berkshire
p. 116	Galleria Doria Pamphili, Rome
p. 117	Des Moines Art Center, United States of America
p. 140	Standaard Uitgeverij, Antwerp
p. 143	Graphische Sammlung Albertina, Vienna
p. 147	Hermitage, St Petersburg
p. 148	Mattel, Inc.
p. 152	Cabinet des Estampes, Paris
p. 153	Metro Pictures, New York
p. 163	AFP, Paris
p. 167	Koninklijk Museum voor Schone Kunsten, Antwerp
p. 171	Van Gogh Museum, Amsterdam
p. 180	Van Gogh Museum, Amsterdam
p. 203	Van Gogh Museum, Amsterdam
p. 204	Van Gogh Museum, Amsterdam